TED GRANT

Thelma Fayle

TED

SIXTY YEARS OF LEGENDARY PHOTOJOURNALISM

GRANT

VICTORIA · VANCOUVER · CALGARY

Heritage House Publishing Company Ltd.
heritagehouse.ca

LIBRARY AND ARCHIVES CANADA CATALOGUING IN PUBLICATION

Fayle, Thelma, author
 Ted Grant : sixty years of legendary photojournalism / Thelma Fayle.

Includes index.
Includes over 100 photographs by Ted Grant.
Issued in print and electronic formats.

ISBN 978-1-927527-34-4 (pbk.)—ISBN 978-1-927527-35-1 (epub)—ISBN 978-1-927527-36-8 (pdf)

 1. Grant, Ted, 1929–. 2. Photojournalists—Canada—Biography.
3. Canada—History—20th century—Pictorial works. I. Title.

TR140.G73F39 2013 070.4'9092 C2013-903379-3 C2013-903380-7

Edited by Lara Kordic
Proofread by Kate Scallion
Cover and book design by Jacqui Thomas
Front cover photo: *Pierre Trudeau*, 1968.
Back cover photos (clockwise from the top): *Chernobyl Boy and Car*, 1992; *Charlotte Whitton*, 1958;
A Padre at the War Games in Norway, 1968; *Doctor Dutton*, 1983; *Tangerine Farmer in Japan*,1968; *David Ben-Gurion*, 1961;
and *Jackie Kennedy Watching the RCMP Musical Ride in Ottawa*, 1961.
Spread out slides (page 6): naphtalina/iStockphoto.com; Stack of slides (chapter openers): sx70/iStockphoto.com.
All interior photographs are the property of Ted Grant unless otherwise indicated in the List of Works on pages 217–219.
Distributed in the US by Publishers Group West

This book was produced using FSC®-certified, acid-free paper, processed chlorine free and printed with vegetable-based inks.

Heritage House acknowledges the financial support for its publishing program from the Government of Canada through the Canada Book Fund (CBF), Canada Council for the Arts, and the Province of British Columbia through the British Columbia Arts Council and the Book Publishing Tax Credit.

16 15 14 13 1 2 3 4 5

Printed in China

For

Daryl Jones—Irene Grant was right about you

Janet Powell—a true friend

Barb, Judee, Les, Heather, Robert, and Doris—my sibling teachers

Courage is the price that life exacts for granting peace.

AMELIA EARHART

CONTENTS

FOREWORD

Ted Grant's friends are as many and varied as his photos. From working at the Olympics to working in operating rooms, from the plains to political capitals, Ted has met and befriended thousands of people in Canada and beyond. In 1976, shortly after the Progressive Conservative federal leadership convention, Ted "joined" our family and would remain a part of our lives for the next four decades. Every major political and personal event was caught by Ted's camera—from the photo of our daughter the day after her birth to the 1979 election victory and the ups and downs that followed. In 1981, he and Maureen published a bestselling book together on the residences of Canada's political leaders.

There are many good photographers in the world. But Ted is unique in both his style and his approach. For one, he has the uncanny ability to be both in the room with you and invisible at the same time. The click of his camera, even in situations of silence, goes unnoticed as he captures a moment in history. Most photographers change the photo to suit themselves, moving the subjects at whim until they achieve what they want—but not Ted. His patience knows no bounds, and he will wait all day if he has to in order to translate the most important moment for posterity. He looks not for the quick shot, but for the story behind the photograph. He anticipates a photo and then waits for it to appear. Ted has the rare gift of empathy and offers it to all whom he captures with his camera. He tells a story of the people he photographs—be they pediatricians and nurses in Chernobyl, an Olympic gold medal winner, a wizened old cowboy, or his beloved Irene.

This book reminds us of Ted's enormous talent and gives us an idea of the breadth of his understanding and skill as a photographer. But it also shows us how a kind, determined, generous, and brilliant man has made one of the greatest contributions to our country's history through the lens of his camera.

—RT. HON. JOE CLARK AND MAUREEN MCTEER

INTRODUCTION

opposite

John Evans Portrait Shot of Ted Grant, News Photographer, 1953

Twenty-five years after taking a course called "The Magic of Light in Photojournalism," I decided to look up the instructor and email him a question with the subject line "Downright Bold Request." If I had known then what I know now about Ted Grant's accomplishments, I might not have had the courage to contact him.

Dear Mr. Grant,

You taught an evening course at Camosun College twenty-five years ago. I have never forgotten some of the things you said in that class—about how your wife gave you your first very simple camera, and how to catch early morning sunlight when it is only perfect for minutes, and why it is important to carry raisins in your camera bag.

I am thinking of you today because I interviewed a very accomplished man, who is a highly respected activist in Victoria. He has a physical disability that he has gone to great lengths in his life to overcome by way of beautifully developing other parts of himself. I intuitively feel you would understand the best way to photograph this man for a local magazine profile I plan to write. I wonder if you could give me some tips please.

Is there any chance at all that you would be willing to chat with me about this idea? I did a late-life degree in non-fiction writing and so I am a junior writer. You are, frankly, out of my league, but I wanted to ask you, just in case there is a chance. I imagine you are busy, and I appreciate your time. Thank you kindly for considering this odd request.

Sincerely,

Thelma Fayle

Within an hour this email response came back:

Yes I'm busy, no question. However, why shouldn't we have a chat about your story and see where we may or may not go with it? And if we can put something together to make it work?

My wife and I are home all weekend and here is our phone number . . .
Over to you,
Ted

Ted and Irene Grant arrived at my house for tea, and we talked like old friends at my small kitchen table for three hours. At the end of our chat, Ted, then in his late seventies, stood up, walked over to my fourteen-year-old part-timber wolf dog and proceeded to lie down next to her, flat out on his belly, on my kitchen floor. Without saying a word, Ted lifted his Leica and took an eye-to-eye photograph of lovely old Spirit. I instantly became a Ted Grant fan.

Ted offered to accompany me on the interview and completely disappeared from my radar once we got there. I was able to focus on the man I was interviewing and had his full attention. An hour later, Ted came out of the shared interview/photo shoot with stellar shots. His kind offer of help was the start of an incomparable working relationship. I wish every writer could experience teamwork with a photojournalist of Ted's calibre. His work ethic and respect for the people he photographs is singular. When it comes to integrity in his art, Ted Grant is of a different era, like a Will Rogers or a Mark Twain in his field.

"If there is one thing I know for sure," he said as I drove him home that first day, "it's that you get what you give in life."

As you read through these pages, I hope you will get a sense of exactly what he has given to Canadians and how much he has received from life in return. Through fifty interviews with him, I have come to know a man who laughs easily, works hard, loves his family, and found a best friend in his wife of sixty-three years—a man who has created a life that is a substantial work of art in itself. He speaks from his heart as a matter of practice. He is a born teacher. He cries freely when he is moved. He admitted to me that he once failed to carry out an assignment to photograph a police officer pulling a toboggan carrying a drowned young boy. He was crying too hard.

This book is a weave of biography, monograph, and technical guide. Rather than just focus in on the subject's life, Ted's interior landscape, this story also mirrors an exterior landscape. Under a wider light, and in the context of the rapidly changing field of photojournalism, it is a book about pictures taken over the better part of a century—pictures that tell intimate stories about where we live, how we think, and what is important to us. We need to think about our pictures.

Most Canadians know the work of the photojournalist who captured Pierre Trudeau sliding down the banister, Ben Johnson in his brief moment of glory at the 1988 Olympics before he was stripped of his gold medal in a doping scandal, Sue Rodriguez in her dignified right-to-die campaign, and the sad faces of the children of Chernobyl. But few people know Ted Grant's name. In my effort to introduce him to you, I visited the Ted Grant Special Collections at both Library and Archives Canada (LAC) and the National Gallery to view a large part of the more than 300,000 archived images that compose Ted's lifework.

Time and again, in very different environments, Ted has instinctively known what to look for and how to capture it. He follows his gut. And his joie de vivre—like Mr. Trudeau's as he slid down the banister—has led Ted Grant to take the right photographs. He claims he is lucky and he just "sees it and shoots it." But no one could be that lucky.

One of the challenges of this book has been selecting a relatively small number of photos from a collection of hundreds of thousands. Had I chosen a specific genre, I could easily have given you a sampling of some of the very best photos ever taken. Instead, I chose to select images that spoke to me. His sports photos from the Olympics and his highly acclaimed medical shots are world class, but so are his photos of average people. Other than Ted and the archivists, I may be the only other person to have looked at the entire body of his work. After studying and reflecting on it, I better understand the importance of documenting Canadians, as the National Film Board (NFB) stills division did so beautifully for a time. Ted's overview of Canada's diversity reveals a cumulative richness—the vigour of a country of immigrants and First Nations. Ted's work shows us the richness of our ancestral heritage in a way that feels as satisfying as if we were looking at our own family photos. I was left with a sense that, consciously or not, we are all affected by events that took place in earlier generations in our country.

If Canadians could see the richness of their own reflected images in the Ted Grant Special Collections in our national archives, they would know a little more about the

importance of their individual roles in our nation. I believe there is potential for healing in the future if we consider the palpable connections to our collective past.

In my research at the archives, I was surprised to find pictures taken in 1964 in the Canadian National Railway (CNR) workshop in Pointe-Saint-Charles, Montreal, where my father worked as a coppersmith at the time. I am certain my father would have been proud to know his role as a blue-collar worker held significance in the thoughtful eyes of a world-renowned photojournalist.

In another photograph (which I call the "windmill picture"), a man operating an industrial dishwasher stands in a dark corner of the kitchen at Our Place, a homeless shelter in Victoria, British Columbia, with his face to the wall. Until recently he had been unemployed and living on the street. Being hired as a dishwasher changed his status, and he worked hard to show that he could do the job well. Ted took a shot that shows each of this man's arms doing different things. His left arm is stretched out with a hand picking up dishes and filling the trays entering the machine. At the same time, his other hand is stretched to the right, unloading the machine. He is sweating and his arms look like a spinning windmill.

When Ted gave the man a "happy snap" the next week, he barely received a thank you. The man looked at the photograph, put it back in the envelope, and left with it. The following week the man told me he knew it was a special picture, and although he had never spent so much on a picture frame in his life, he decided to "fork out ten dollars for one." He said the picture was hanging on the living room wall at home, and his family was proud of him. He lost his job shortly after when the challenge of addiction got the better of him, but he has a picture that may inspire him to try again one day.

Ted's work shows he is in touch with what is important in people's lives. Unlike many of his contemporaries who chose to strictly specialize in a narrow subject area, Ted Grant grew to become that rare breed of photographer who is both specialist and generalist. And, as often happens with creative professionals, Ted was never an extraordinary businessman when it came to negotiating contracts to his best financial advantage. In fact he probably gave away more "happy snaps" than he could ever count. It has only been in recent years that Ted has started to receive public recognition.

Ted Grant: The Art of Observation, a 2007 documentary produced by Heather MacAndrew and David Springbett, exquisitely chronicles Ted's story and the numerous national and international awards to his credit. After six decades of working as a freelance photojournalist, Ted was bestowed with an honorary doctorate by the University of Victoria. When the notice of the tribute arrived in the mail, he thought it was for his son, Ted Grant Jr., a highly respected high school teacher. His reaction speaks to the decades he spent behind the scenes, away from the limelight of his famous subjects.

Plenty of people have had inspiring careers, but few share them as willingly and eloquently as Ted. What really struck me while conducting over one hundred hours of interviews with him was how one story quite naturally led to another. He is a raconteur with a storehouse of good yarns and pictures to go along with them. *Ted Grant: Sixty Years of Legendary Photojournalism* is not just about one man's work; it is about a collective human identity. Although his work is certainly international in scope, for the most part I have focused on Canadian subjects in this book. My intention is to describe the lifework of a person I respect and admire, and I must admit that my admiration sometimes got in the way of my attempt to present an unbiased view. I expect you, too, will come to admire Ted for his humanity, seen at the core of his work; his love of life, the most important factor in his success; and his distinctive voice, which fills these pages.

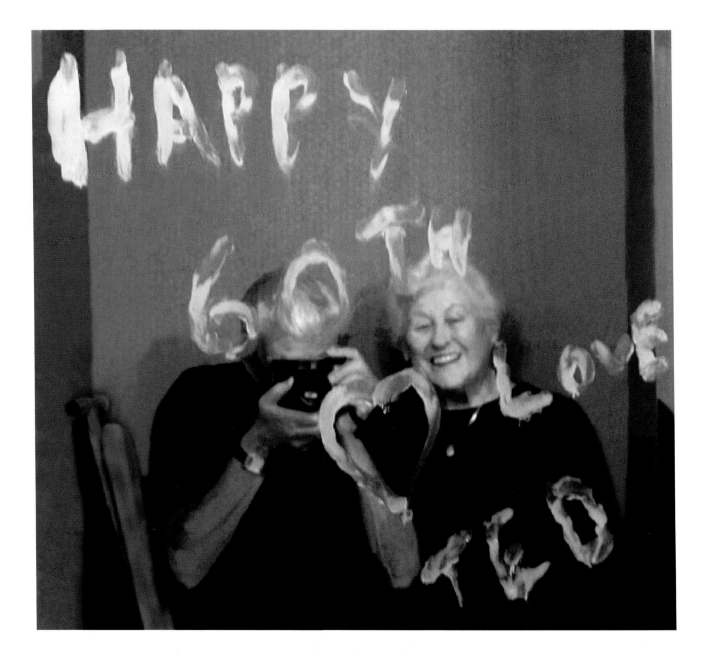

1 GIFT OF A LIFETIME

A TRIBUTE TO IRENE GRANT

She opened a door to a life career beyond anyone's wildest imagination. Many thousands of miles around the planet, exciting countries and assignments—Irene triggered it all.

TED GRANT, 2013

Ted Grant knew he was in trouble when he woke up in a hotel room on his wedding anniversary and realized he had forgotten to buy a card for Irene. He knew very well that she would have one for him. In the Cape Cod resort where the international Leica seminar was being held, and where he would be a guest speaker later that day, there were no greeting card shops open at 5:00 a.m. So he tiptoed into the bathroom, uncapped the tube of toothpaste, and smeared "Happy 60th Love Ted" on the mirror. A little later, after he'd gone back to bed and dozed off, he woke up to the familiar sound of Irene's laugh.

Judging by her smile in the picture, Ted's hallmark spontaneity was just fine with the woman who had kick-started Ted's career way back in their first year of marriage when she bought him a little $30 Argus A2 35 mm camera for his birthday. As a young bride, Irene had listened well and knew something of her new husband's childhood curiosity—one that had been ignited on Sunday morning outings with his father and an old Brownie camera.

Sixtieth Anniversary, 2009

After forgetting to buy his beloved wife, Irene, a card on their sixtieth anniversary, Ted snuck into the bathroom at 5:00 a.m. and wrote her a message. "You'll notice there's no flash, of course," quips Ted, always the professional.

"IRENE GRANT IS a saint."

That is what I told her, when Irene jokingly asked what I was going to say about her in the book. She laughed.

"Good," she laughed. "Could you put a picture of a little angel with wings over my name?"

I did not think about her comment until a month later, March 2012, when Ted's best friend and wife of sixty-three years died suddenly after a brief illness. Ted and their four grown children and ten grandchildren collapsed into sadness at the loss of the family anchor. They braced themselves. Everyone feared and expected Ted's imminent demise. For years, friends and family had surmised in whispers that Ted would never survive without Irene.

In some ways, theirs was a traditional marriage. Irene did everything around the home and Ted travelled all over the world for work. At eighty-three, Ted did not know how to use the stove, or the washer and dryer, among other things. While Ted was away on assignments, Irene raised their four children. "She did it single-handedly for the most part," Ted duly credits her. When Ted Jr., Cyndy, Sandy, and Scott were in high school and Irene was in her early forties, she decided to go back to school to become a nurse. She enjoyed a two-decade-long nursing career before settling in to a well-deserved retirement. That was Irene.

With the help of a strong network of family and friends and former colleagues from around the world, Ted started to cope with the largeness of his grief. Reminders of Irene in their home brought both anguish and comfort as he began to figure out how to learn to live without his strongest supporter and critic.

"It's Day Four," he told me when I arrived at his home for a previously scheduled interview—as in Day Four without Irene.

Ted stared into space for a time and cried a great deal in those first months. (Unlike many men of his age, Ted has always been able to cry and grieve in a healthy way.) It was a raw and painful transition, and he stumbled through it one step at a time. Yet in spite of the almost unbearable sadness, Ted was determined to find some semblance of beauty and purpose in each day. A few months later, when he grew a little stronger, he decided he was not going to live with grief—grief was going to have to learn to live with

him. With the support of his family, he continued with our interviews for this book. He wanted to give back or pay forward, if you like, for the gift of a lifetime that he had received from Irene.

IN THE 1930S, people called it a lazy eye. Ted Grant had one. The doctor gave him a patch to wear over his good eye, intending to strengthen the weaker right eye. Ted headed back to class at Toronto's Franklin Public School, where he was promptly told by his teacher to "take that thing off." She thought he was being the class clown. Corrective lenses in high school didn't help much either. They might have, but after the third pair broke when Ted was playing sports, his parents finally gave up on trying to treat their son's affliction.

Edwin James Grant and Margaret Turner had emigrated from the UK and met and married in Toronto. They got by well enough on Edwin's salary as a transport truck driver and part-time mechanic, and on Margaret's pay as a charwoman and worker in a munitions factory. But with two children to feed, a fourth pair of glasses was not in the cards for young Ted.

The eye problem never held Ted back—but he did see things differently. He would eventually become a left-eyed photographer, though 98 percent of mid–twentieth century photographers used their right eye for the viewfinders on film-loaded cameras.

Aptitude tests at Danforth Technical High School showed Ted could "work with his hands." What the aptitude tests did not pick up was that even with only one good eye, Ted delighted in the art of observation, and despite his boyhood shyness, he related exception-ally well to people. Fortunately for Ted, he was hard-wired to follow his own instincts to continually find more fulfilling work. After his third year of high school, he dropped out to take an assembly line job at the old Rogers Majestic Radio plant in Leaside. He was barely in the door when someone picked him out to work in the service department. That first promotion eventually led to a service position with Hobart Manufacturing Company. Ted's friend Roger Irons worked at Hobart and invited him to a house party one weekend. It was there that Ted met Roger's sister Irene.

Wedding Day, 1949

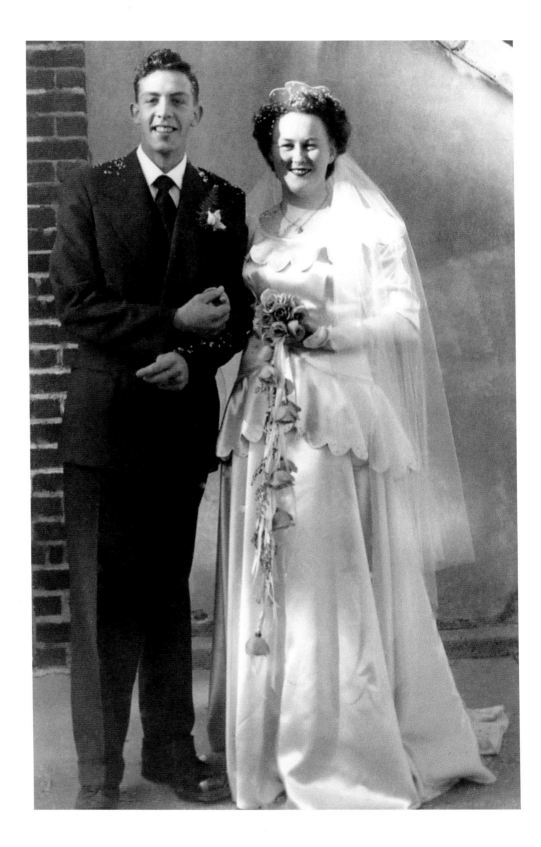

"Irene was this beautiful blonde-haired girl, and I just about fell in love with her as soon as I saw her," Ted recalls. "We connected from the first moment."

Ted immediately invited Irene to a show, and the two were inseparable until Hobart transferred the young, fully trained serviceman to Ottawa. Undeterred, Ted and Irene set a wedding date for October 15, 1949, and rented a little flat on Powell Avenue with three rooms and a big sun porch.

Ted and Irene on the Street, 1952

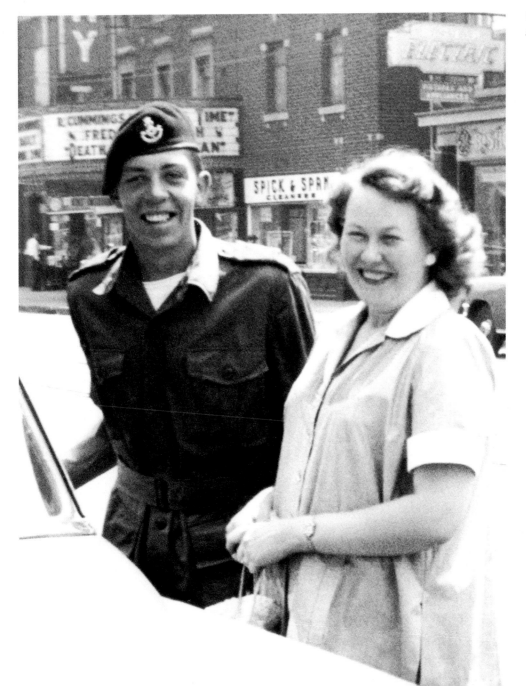

Ted and Irene on a Motorcycle, 1948

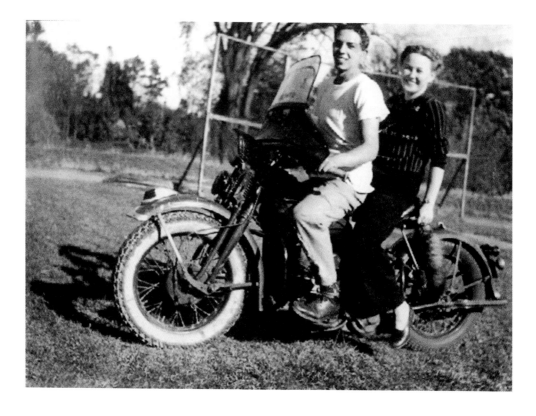

Ted and Staghound, 1952

Ted as a young commissioned officer in his early military reserve years is standing beside an armoured car called a Staghound. In this shot he was participating in reconnaissance work in 1952.

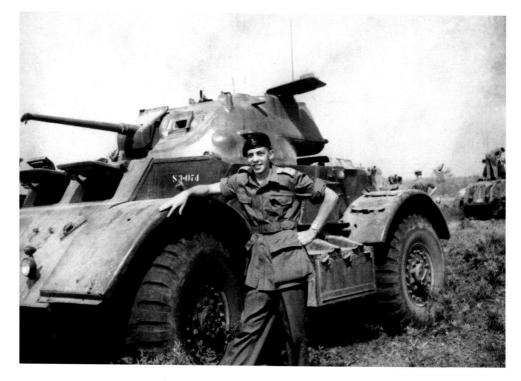

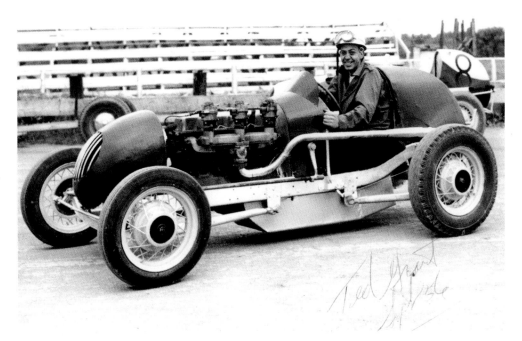

One warm fall night in 1951 with dinner out of the way, the newlyweds, both twenty-two, headed down to the stock car races at Lansdowne Park, where Ted spent a lot of time either racing in a stock car or taking pictures. That night he was taking pictures. He put a roll of Kodak film in his birthday gift from Irene and placed the camera in his pocket. They paid their buck to get in and planned to sell prints to the stock car drivers for a dollar apiece.

That night, Ted sold his first picture of the stock car races to the city editor at the *Ottawa Citizen* for three dollars. When he saw his first "Photo by Ted Grant" credit line, published on September 17, 1951, he was hooked.

Around this time, Hobart put Ted on the road as a sales rep, and he used it as an opportunity to take pictures wherever he went. When he saw a job with the NFB advertised, he began to get a sense of the different opportunities that might be out there for him. He did not have enough experience for that job, but he was determined to break into the field. He applied for a position with the Department of National Defence thinking he would be a photographer, but ended up working in the darkroom helping make military ID photos from hundred-foot-long rolls of film. It was a start.

A turning point came when Ted and his buddy Lorne Soloway, an amateur photographer friend, heard on the radio that there was a train wreck up in Gatineau on a holiday weekend. The two men bolted to the scene and shot rolls of film. The next day, they went to the *Ottawa Citizen,* the *Ottawa Journal,* and *Le Droit* to try to sell their work. All three papers were interested. Soloway encouraged Ted to develop his own film and make his own prints.

"We used the kitchen after dark and Irene's baking tins until they all went black," Ted recalls. "Irene was annoyed and I eventually had to buy her a new set."

After the train wreck pictures were published, Ted, then twenty-three, joined a well-established photography agency in Ottawa. Within two years of receiving the camera from Irene, he was working as a full-time photographer.

When I look back over the last sixty years of my freelance career, there is a funny feeling about me still being here and Irene not being here. In some ways it feels hollow without her.

Irene was my greatest critic. She tolerated no sloppiness with camera handling. I have never run into a better photo editor on the outside. She did not like stupid angles. She would say, "Why didn't you go and stand over there?"

Yogi Berra, the great American baseball player, is often quoted as saying "You can't think and hit at the same time." Irene followed that up with "You can't think and shoot at the same time." She was the first to put it into words for me. See it, shoot it. She made me a better photographer.

Irene looked after so many things in our lives. I had no idea. She had an account that she half-jokingly called her "running-away money."

I bet she had it for fifty years. I never knew how much was in there; I just knew she always stood pretty strong about not wasting our hard-earned money. When I learned the amount after her death, I was totally surprised. I am more comfortable in life now because of her effort, as has always been true.

Robin Rawson, a boisterous Victoria hairstylist who has been cutting Ted and Irene's hair for twenty-six years, teased Ted about knowing the real purpose for Irene's running-away money.

"Irene told me it was always meant to be your bail money, honey."

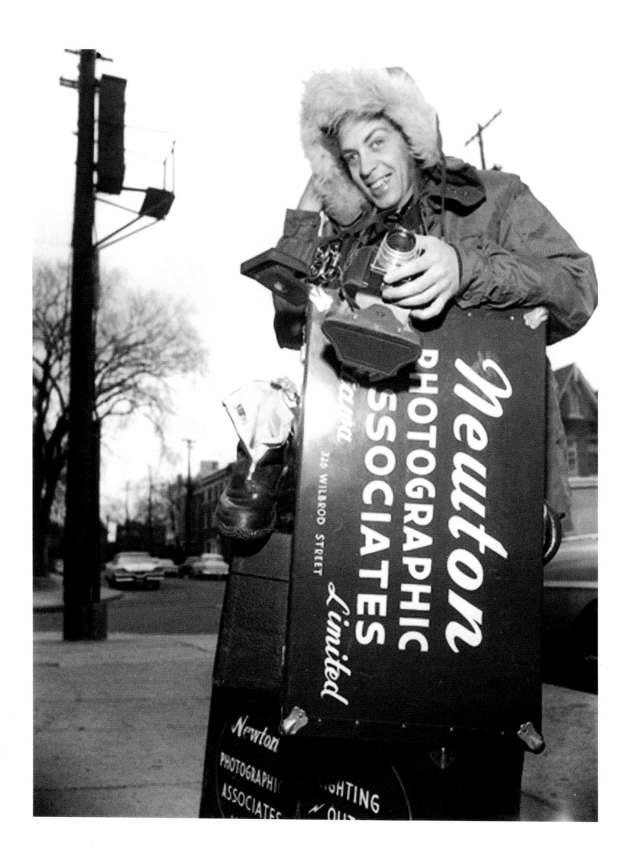

2 OH, TO BE A COWBOY!

CAREER HIGHLIGHTS

I worked in journalism and the teaching of journalism for more than fifty years. I met a lot of trustworthy and praiseworthy people who were great professionals in their field, but none greater than Ted Grant.

LINDSAY CRYSLER
Retired Director of Journalism, Concordia University, September 2012

If Malcolm Gladwell's theory, as suggested in his book *Outliers*, is correct, the intensity of Ted Grant's shooting regimen in his early years might be a factor in his ultimate success as an outlier. Ted Grant completed his initial ten thousand hours of photography practice before he was twenty-five years old—not bad considering he only received his first camera when he was twenty-one. The calendars from Ted's first years in business show a jam-packed schedule. A variety of cameras and lenses, and often hundreds of canisters of film, flashes, and other gear added up to a heavy load for a person who needed to constantly be on the move. Ted learned early on that staying in shape was important for a photographer.

By the time Ted was thirty-five, the foundation of his career had been set. He learned to trust his gut. He learned to recognize the best lighting by instinct. He did not need to take time to think about F-stops. He knew his equipment, and his motto became "Shoot first and ask questions later."

opposite

Ted and Newton Photography Sign, 1954

Ted holding the sign of his early employer Newton Photographic Associates, where he quickly advanced from the darkroom to the field. "The pros at Newton seemed to see something natural in me and knew that I just needed polish to bring it out. They helped me understand what I was doing," Ted recalls.

Ted's career as a photojournalist was taking off at a time when many freelance photographers worked within a two-hundred-kilometre radius of their home base. But Ted was venturing farther afield than most of his contemporaries. His way of seeing the world with his one good eye was evolving. He was determined to use that good eye "for more than to keep me from bumping into telephone poles." And he was getting well paid to do something he loved.

At Newton Photographic Associates he started honing his darkroom skills. Before long, Mr. and Mrs. Newton moved him into shooting assignments and asked him to be a full-time newspaper reporter.

Speed Graphic Shot, 2012

Ted posing with the rather unwieldy Speed Graphic camera he used in his early days as a newspaper reporter.

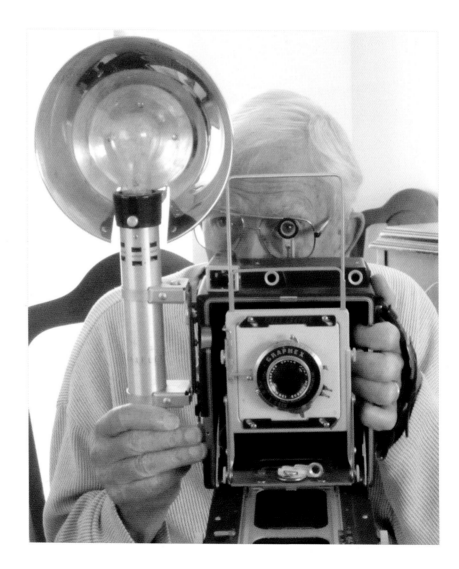

"When I started, they gave me a 4 x 5 [sheet film] Speed Graphic camera," Ted recalls. "I picked it up and had no idea how to make it work."

The Speed Graphic is recognized as the famous American-made press photographer's camera, used mostly in the 1930s, '40s, and '50s. It had a big flash bulb and weighed almost nine pounds.

Ted—New Photographer and Baby on Street, circa 1952
Ted snapping a picture of a baby on the street in Ottawa.

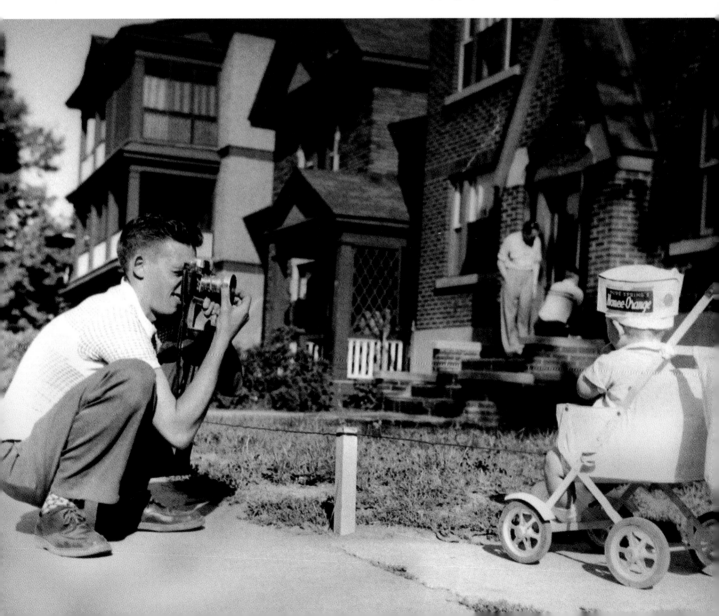

**Rolleiflex Camera,
circa 1955**

Ted also learned to
use a Rollei, short for
Rolleiflex, a German
camera that used 120
film. There were twelve
exposures to a roll
and a 2¼-inch square
negative. The camera
had twin lens reflex, and
you had to manually
advance the film.

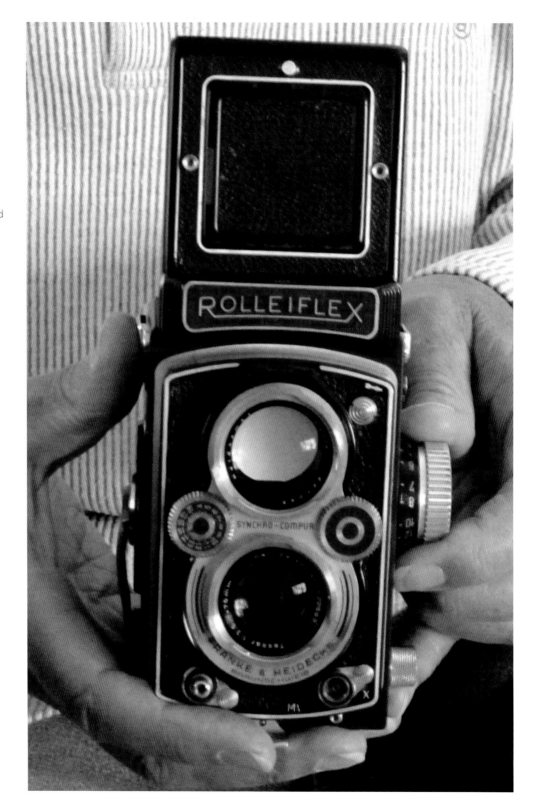

Ted was exposed to the work of fifteen photographers at Newton—all highly skilled and all willing to help a rookie learn the art of photography. He learned about the nuances of backlighting and composition from exceptional portrait photographers, news photographers, and a plucky chief darkroom manager who had been at Newton for years.

Stan Hunt was nearing the end of his long career and considered rolls of film to be of "inferior quality" compared with the sheet film used by the tried-and-true Speed Graphic. Hunt was a craftsman who wanted nothing to do with rolled film and dismissed the Rolleiflex as being nothing more than a "toy camera." When Ted used 35 mm or 120 film at Newton, he made sure he had time to develop it himself. Nobody argued with Stan Hunt, least of all the greenhorn.

Cliff Buckman, an award-winning news photographer, helped Ted understand how to document the news. Bil Lingard was the commercial guy who taught Ted about portrait lighting. He sat at Ted's dining room table in Victoria laughing and reminiscing with Ted some sixty years later. Andy Andrews, who connected Ted with the *Ottawa Citizen* and Newton, was Ted's most influential mentor when he first started. Ted describes Andrews as his "guardian angel."

> *Every minute that I was not doing my daily job, I was with Andy. He would call and say he had two to three assignments in an evening and invite me along. I was his grip. I would hold the second strobe flash units. I didn't get paid and I didn't worry about it. I knew working with Andy had value. It was one-on-one learning from the best. And it was fun and exciting.*
>
> *He taught me how to deal with people who were grumpy or shy—and how to make people feel at ease. He made me realize that the way you treat people is critical to getting great shots.*

Andrews's advice made sense to the boy who had grown up in the '30s and been taught to "respect your elders and have some manners." Treating people respectfully was a lesson Ted refined and a quality he came to be known for throughout his sixty-year freelance career.

"I may sound like an old guy," Ted jokes, "but I am right about this. I have come through observing over eighty years of life in my country, and I can tell you: There are times when you need to take your hat off."

TED STARTED HIS work with the 35 mm camera from Irene, but also used the Rollei for news assignments rather than "lug around" the big and heavy 4 x 5 Speed Graphic. Later, Ted used the Hasselblad—a single-lens 120 film (as opposed to 35 mm) camera made in Sweden—for news and documentary photos. He used three Hasselblads, each with a different lens (a semi-telephoto, a regular lens, and a super-wide) to save time rather than switching lenses. Similarly, when he needed to change from black-and-white to colour film, Ted found that he was less likely to miss out on a shot if he had several prepared cameras. Ted, like other photojournalists of the era, had to get used to working that way—draped in heavy cameras with pockets full of film.

The worst part of the job at Newton was being assigned the usual Saturday morning Catholic wedding and Saturday afternoon Protestant wedding. Ted was far more interested in shooting the Ottawa Rough Riders when they played against the Toronto Argonauts. Even high school sports were more interesting than the dreaded weddings. As soon as he amassed some seniority at Newton, he stopped doing them altogether.

PHOTOGRAPHING HIGH-LEVEL PEOPLE is routine for any professional photographer in a capital city. But Ted's first experience of meeting a prime minister filled him with respect and fondness.

> *I was a rookie in my early twenties doing an assignment for the* Ottawa Citizen *at an opening of an art gallery in the late 1950s. Prime Minister Louis St. Laurent and one or two RCMP officers were there as part of the celebration. I was the only photographer.*
>
> *I explained to his executive assistant that I had never photographed a prime minister, and asked how I should address him and if it would be okay to ask him to do something. "Do I call him 'Sir,' 'Mr. St. Laurent,' or 'Prime Minister?'"*

The assistant looked at me and said, "Sure, they'll all work. What would you like him to do?" I told him I wanted a picture of the artist and the prime minister standing next to a big painting.

He went over to the prime minister and explained that I was a rookie and told him about my questions. The prime minister, referred to in the media as Uncle Louis, walked over, said hello, and asked what I would like him to do. I told him what I needed and he said, "Oh, that will be fine." Then he asked me if I would like to take another picture. "Uh, no, Sir, it's fine, thank you." Then he walked over to me and thanked me. He was a respectful and gracious man. Meeting him was a powerful early experience.

Photography was never a nine-to-five kind of job, and Ted had no off switch when it came to being there for assignments. When his Christmas dinner was interrupted by a call telling him that the Russian embassy was on fire, he picked up his bag and went off to work. He was always motivated by the challenge and always satisfied by the work itself.

Aside from his colleagues at hand, Ted remembers being inspired in those days by Louie Jakes from the Canadian publication *Weekend Magazine*, and Alfred Eisenstaedt and Ralph Morse of *Life* magazine. *Life* epitomized the kind of photography that Ted was determined to create, and he knew that he would sooner or later have to branch out on his own if he wanted to direct his own future.

On March 1, 1959, Bil Lingard, Cliff Buckman, and Ted decided to start their own company, Photo Features. The three new partners put up a sign on the door: HAPPY ST. DAVID'S DAY—WE ARE OPEN. Ted saw their start date as a good omen given that St. David was the patron saint of Wales and his own heritage was 50 percent Welsh. His background was also an (admittedly weak) excuse he gave years later for committing the absolute Ottawa no-no of chatting (more than necessary) with Charles, Prince of Wales, when he was assigned to take the prince's photograph in Ottawa.

The three men set their new fees at $100 a day and were pleased to be credited by name for their work, unlike at Newton where the agency was credited. An early assignment for the *Ottawa Citizen* left a lasting impression on Ted.

I was assigned to go to a major home fire down in LeBreton Flats and I had no idea I was about to do something that I would feel bad about for the rest of my life. As it was nighttime, I was using the flash on my Speed Graphic to photograph the firemen carrying out three bodies on stretchers. A man was standing nearby and he came after me and started yelling.

The covered bodies were his three dead daughters. I was scared and felt terrible. I had never been in that kind of a distressing situation. I didn't know they were children or that the parents were there. I just got in my car and left. Even after all these years I have never forgotten about that poor man and how he must have felt.

Ted had his first NFB assignment when he was asked to assist Gar Lunney, a staff photographer, on an assignment featuring an international postal conference. The two spent a week working together on Parliament Hill, and Lunney became a friend and an important mentor to Ted.

Not long after, Lunney was supposed to fly up north to do a story on the icebreaker CCGS *D'Iberville*, but he had just come back from a six-week assignment and needed some down time. He recommended Ted to take his place.

Ted had about two hours to get ready. He raced home, asked Irene to help him pack his winter clothes, kissed her goodbye, and got on board an armed forces DC3 heading for Winnipeg and on to Churchill, Manitoba, then Coral Harbour and Resolute Bay in the Northwest Territories (today in Nunavut). His assignment was to cover the route of the *D'Iberville*. It was the first time in three years that the icebreaker could get through the nearly five-metre-thick ice. Ted walked into twenty-four-hour daylight as they headed to Resolute Bay and was on the ship when it finished its tour and landed at Quebec City almost four weeks later. He flew Trans-Canada Air Lines (TCA) back to Ottawa.

My career would not have happened if not for that first travel assignment —thanks to Gar. The work from that shoot opened the NFB door. I guess they figured this young guy knew how to shoot, and after that they kept recommending me for assignments.

While Ted was shoring up his career, Irene took care of the home and growing family and became, in Ted's words, "a photographic widow." When people asked if she ever got to travel with her husband, she would curtly reply, "No, do you go to work with your husband?" The comments irritated her, but she took them in stride and was always proud of Ted's work.

And she had plenty of reason to be proud as Ted's star continued to rise. In the early '60s, he sold one of his first major photojournalism spreads to *Maclean's* magazine.

> *I shot a war canoe race on the Rideau River and did a series of pictures in the style of a photo essay. I developed all of my 8 x 10 prints and sent them off. They bought the story and sent along a $200 bonus because they really liked the spread. I felt so good that my work was prominently featured in a national magazine.*

Then, in the spring of 1963, Malak Karsh, an Ottawa photographer and brother of the more famous Yousuf Karsh, invited Ted to go to the Netherlands on a travel-related assignment to photograph tulips for a special event. The project established the start of a long business association, with both men working together all over Canada for the Canadian tourism bureau. One of Karsh's assistants on that first project, John Harquail, was to become a lifelong friend of Ted.

"Ted can hardly go ten feet in this country without running into old friends," says Harquail, who went on to become a corporate location photographer and teach business skills to photography students at Sheridan and Humber Colleges.

On June 1, 1964, Ted started Ted Grant Photography. The accountant at Photo Features had told him he could easily make it on his own, and Irene's mother had generously loaned Ted and Irene $1,000 to start the home-based business. With a newly designated darkroom in the basement by the washing machine, Ted was ready to go.

> *My mother-in-law was a great lady and knew her daughter and I were a good match. I say this despite the fact that over the years, if Irene had had a gun, she would have shot me, and I wouldn't have blamed her. It is a funny part of our sixty-three years together. I don't think two human beings can live together without having some rocky roads along the way—especially in my career.*

Ted approached the car salesman they had used to lease cars when he was at Photo Features and explained he had received a business loan from his mother-in-law and was starting his own business. The salesman knew Ted, had a good relationship with him, and told him to pick out a car. Ted drove off the lot with a brand new Chevrolet and never had trouble with the payments.

It was the same at the camera store. When Ted asked if he could open an account to buy some new equipment there was no problem. Ted dealt with Eastview Photos for years. In fact, one of the staff members who worked there came to a presentation Ted made at the University of Victoria forty-five years later and lined up to shake hands with Ted and have a chat with his old customer.

"It goes back to the importance of how you relate to people," Ted says. "Building rapport is always important. You get what you give in life."

By December that same year, Ted's gross earnings were three times his total salary for the previous two years. The accountant was right: Ted Grant Photography would continue to succeed for almost fifty years.

NOW A FREE agent, Ted worked for the NFB every chance he got. Even though it was less prestigious than the better-known film division, the NFB Stills Photography Division had an excellent reputation. Many exceptional artists gravitated to the organization in the '50s and '60s, when the agency did some of its most pioneering and iconic work. For a government-run agency, there was an amazing pool of creative talent. It was an organization with a clear and interesting mandate: to promote Canada to Canadians, and to promote Canada and its people to the rest of the world—at a low cost.

Working for the NFB during this era remains a point of pride for some of Canada's most important film and photography artists. Every former NFB employee interviewed for this book recalled the era with an identical refrain: "I loved working for the NFB then." The NFB mythology remains strong and relates to a strong identity of innovative artistic spirit.

Ted credits the support of Lorraine Monk, the executive producer of the NFB stills division, for some of his early success.

"That woman did more than anyone to recognize the value of photographers and photojournalism in Canada," he recalls. "I felt that both she and John Ough believed in me and gave me some good assignments."

John Ough, an NFB stills division staff member, was the editor of a wire service that went to at least twenty daily newspapers across the country. For a nominal fee of $25, media outlets would get a well-written, half-page story and corresponding photos about different places and industries in Canada. Ough wrote the stories and Ted supplied the pictures. The photo essays were on display in every embassy around the world. In many respects, these NFB stories really did put Canada on the map in the 1960s.

"We would give Ted a box of Kodachrome film and he would go on an assignment and come back ten days later with the goods," says Hélène Proulx, a retired administrative assistant for the NFB. "He never needed mollycoddling and always did more than you asked. He would add story value. He was personable. People liked him. He was nice to talk to, and he was a good listener. Ted was never pretentious. These qualities may sound simple, but they are important."

John Ough would say, "They are doing something with wood out in BC," and he'd assign me to go and "do something on wood." There was an honour system. I would go for a week and check it out and see if there was a good story there.

I learned so much with every opportunity. I learned about the wood industry. I went to find out how they made shingles and to photograph the process. I learned about the west coast lumber industry, the fishing industry off the west coast, the mining industry, the orchards of the Okanagan, drilling for natural gas. I met the lobster fishermen and the crab fishermen on the east coast.

Ough had so many ideas for assignments. He sent me to do a documentary in Quebec where they were beginning to irradiate vegetables and potatoes. I would go down and introduce myself as being from the NFB and I was welcomed. The NFB had a stellar reputation. Every assignment was always an education about Canada, and I have yet to meet another photographer who was as fortunate as I was in getting so many great assignments. Day after day, and year after year, I was involved in observing the lives of Canadians.

Freelancing for the NFB was a prime opportunity for a young photojournalist. Ted worked independently on assignments and just did what came naturally: taking pictures of everything that interested him. His talent for finding the extraordinary in everyday subjects landed him a place in *Call Them Canadians*, an NFB-produced book of photos about the country and its people. Although he was a freelancer, he crossed paths on many occasions with another legendary NFB name, Chris Lund. The renowned staff photographer earned Ted's respect, and the two maintained a friendship for many years.

By the early 1970s, the NFB's operating budgets were being directed away from still photography and funnelled into the film division. The glory days of the stills division were coming to a close, but Ted had played an important part.

IN THE MID-'60S, Ted was multiple times around the proverbial ten-thousand-hour clock that is said to make someone an expert in their field when he received a fantasy-fuelled assignment on a ranch in Alberta. Being a city boy, born in Toronto and brought up in eastern Canada, Ted had gone through the usual cowboy-wannabe phase. So when the NFB assigned him to cover a cattle drive in Alberta, it didn't him take more than a moment to accept.

Cowboys and ranchers were milling around the cookhouse as I arrived. It was just like a movie set. They knew I was doing a photo essay on their fall roundup for the National Film Board and they welcomed me.

When you are working on this kind of a project, time is meaningless. You get up before the sun only because someone in the bunkhouse rings a bell. It's time to get the fire going and to feed and water the horses. We washed out of a big tin bowl. There were no hot showers. You stumble around and bend your knees, get down low, and put the subjects into silhouette. Every time you see something and you go, "Oh jeeze, look at that," you shoot it without another thought.

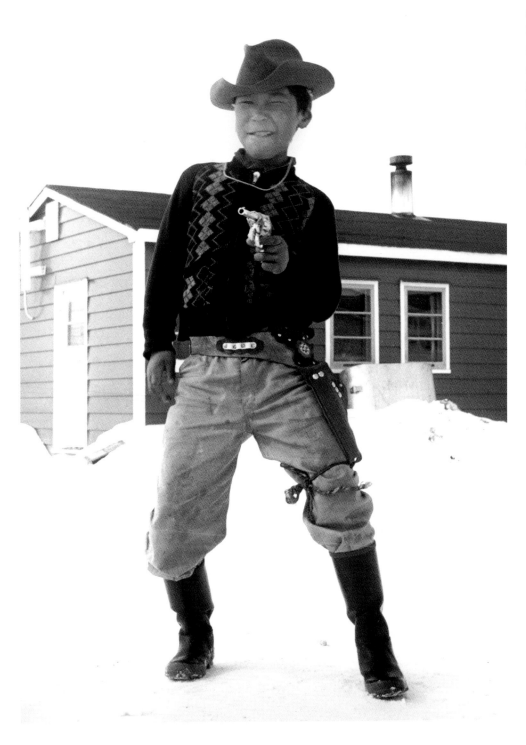

Inuit Cowboy Kid with a Toy Six-Shooter, 1958

This earlier shot of a spirited Inuit boy in Frobisher Bay dressed like a cowboy with a toy six-shooter captures how I imagine Ted might have been feeling en route to High River, Alberta, for his dream assignment.

To be there with real cowboys was great. Some of them had sons who worked in Calgary as executives, but they would come out to be with their dads on the roundup. It was quite something to watch these younger men walk in dressed in suits and then transform into John Waynes.

To make sure I could keep up with the cowboys, I decided to take a few riding lessons. I didn't wear cameras on the first day because I wanted to get comfortable and concentrate on learning to ride. I learned that horses are a lot smarter than people realize—that mare had my number. When the instructor wasn't around, she did exactly as she pleased and dumped me into a manure pile. As I looked up at her, I swear she stood there killing herself laughing at me, as did the ranchers.

One of the men I met was an old-time cowboy who only had one eye and lived by himself in a log cabin. He was about five feet tall and had to stand on a box to get on his horse. I asked him what happened to his eye. He said he was chasing some rangy old cow through the woods one day and something poked him in the eye. He said it hurt for a few days and then it all swelled up and then it all leaked out.

That's what happened. He never even went to see a doctor.

On my final day, I went out to get some shots in the cutting corral, where they separate the cattle by brands. They were castrating, dehorning, inoculating, and branding the animals. I knew all the guys by then and kind of felt they were watching me. I figured something was up.

One of them walks over and invites me to see the branding operation. He offers to hold my camera while I hop a fence, and all of a sudden a couple of them grab me and bring the branding iron over—right out of the fire.

I figured they were joking, but I was a little nervous. I could feel the heat. They were laughing and telling me not to twitch cause it would spoil the brand. Of course they didn't do it, but then they called the castration guy over and they had me on my back, with my jeans pulled off. He comes over with no smile on his face and taps my scrotum with the knife. Then he says, "Okay, he's done. Spray him." And the guys spray me from belly

continued on page 43

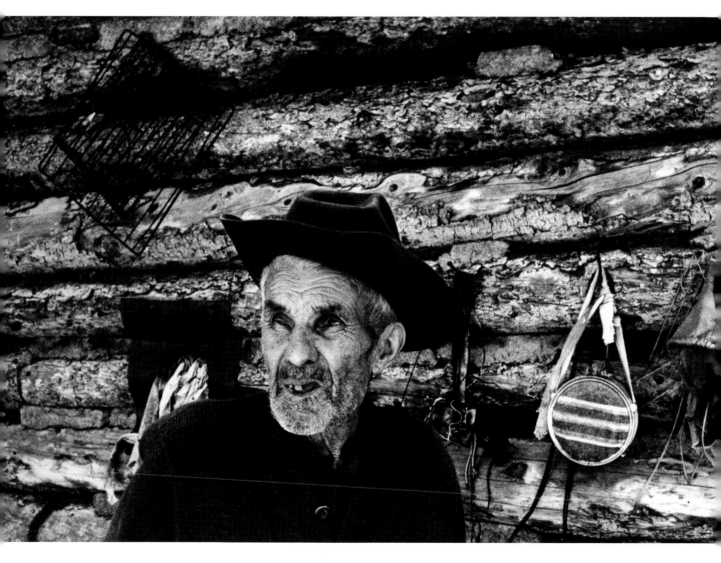

Rugged Cowboy with One Eye, 1965

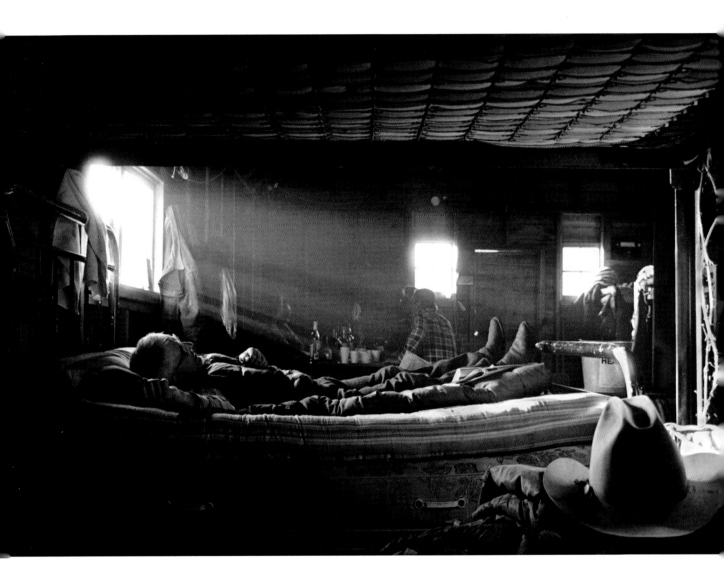

Cowboy Napping in the Bunkhouse, 1966

Ted captures a spent Alberta cowboy sleeping beneath rays of brilliant sunlight while his pals spin yarns over coffee and whiskey dregs in the background.

button to knees with a purple disinfectant. Just as I got up, they threw my clothes in the field and I had to run around and grab them. I had to fly home that night and explain to Irene why I was purple. She thought it was hysterical.

I may forget the names of individuals but I will never forget the fullness of the assignment. The camaraderie with those ranchers was really fun.

Ted shot colour transparencies, slides, and Kodachrome, and when he returned to Ottawa from the Alberta assignment, he worked with his NFB colleagues to put together a slide show that used twelve projectors and included a soundtrack. Ted had recorded the whooping and hollering of the cowboys on the ranch, and the sound people cleaned it up and created a soundscape to a huge panoramic theatre of changing images. The production was shown in Ottawa, and Ted's work was the catalyst for the idea to produce a book about cowboys. *Men of the Saddle: Working Cowboys of Canada*, a collaboration between Ted and Andy Russell, was published by Van Nostrand Reinhold in 1978.

As with all of Ted's work, one assignment seemed to lead to another. Hollywood actor John Travolta was preparing for his role in *Urban Cowboy* when he received a copy of Ted's book and decided he wanted to work with its photographer. Ted was travelling with Joe Clark and the media entourage on a federal election campaign when he had a message to contact Paramount Studios in LA. The message simply said they were looking for his "expertise." Ted thought it was a joke being played on him, so he returned the call collect.

Paramount sent Ted the contract outlining the strict union rules for photographers in Hollywood. The per diem was $650 for the five days they wanted him there. In addition, they paid $1,000 for days when he took photos and another $1,000 if they used one. If an artist did a rendering of one of his photos, they paid an additional $1,000 per shot.

Airplane tickets were sent and a hotel arranged, and Ted was on his way to Houston, Texas, to Gilley's, the nightclub where the cowboy movie was being shot. Staff met him at the airport with a huge limo, picked up his bags, and delivered him to his hotel with instructions to be ready the next morning when a driver would pick him up.

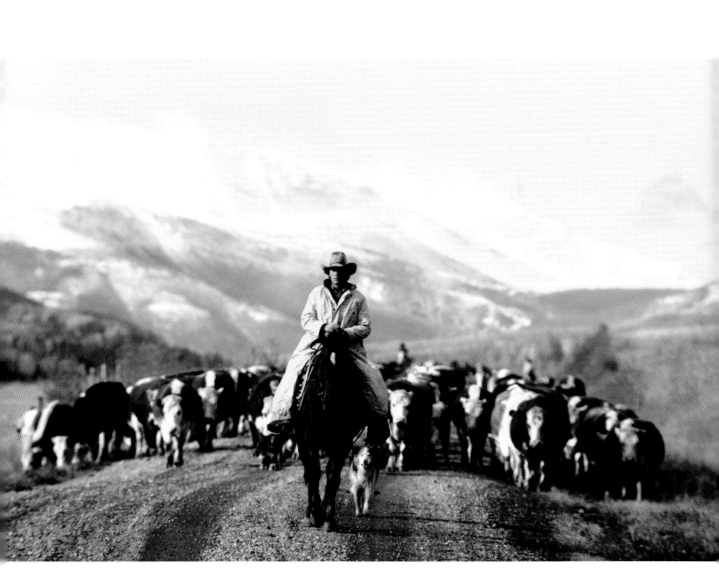

Cattle Drive, 1966

In this photo from *Men of the Saddle*, a cowboy leads a herd of cattle across an idyllic Alberta landscape.

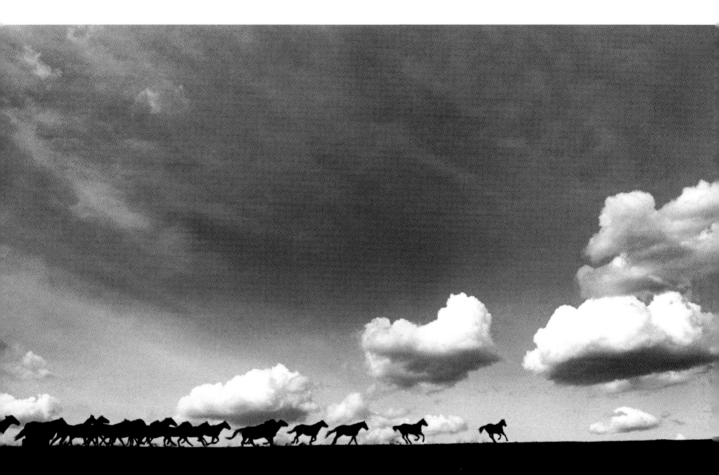

Wild Horses, 1966

This shot, taken in High River, Alberta, shows a pack of workhorses turned loose. These horses were used by cowboys to carry backpacks containing lick salt and other supplies for grazing cattle. Once the job was complete, the horses were allowed to run free until winter, when they were rounded up and housed for the season at the home ranch.

**John Travolta Lasso Shot,
1978**

Although the beard
would be left on the
cutting room floor by
the time *Urban Cowboy*
was released in 1980, an
unshaven John Travolta
stood tall against
the Houston skyline
while promo work was
being done for the
movie.

I was beginning to really like being on the film set and was blown away by all of the attention. The next day, John Travolta came over and said hello and "glad to have you on board." He told me he liked Men of the Saddle. *I just sat back and watched the marvels of a Hollywood production. For fun, they actually invited me to participate when they needed another body in a scene. They put a cowboy hat on me and put me in as one of the line dancers on the floor.*

I started taking pictures of everything so I could show my kids what a movie set was like and was quickly told by the union guys that I was there to shoot the promotion photography and nothing else. They had a pinball machine called Earth Invaders, *so I go over and play for a while and the next thing I know John Travolta says, "I bet I can beat ya." And I said, "Oh, really." Sure enough he beat me and then invited me to the leased house for lunch and supper with the other actors.*

As always, Ted got to relive the whole experience of the assignment as he pored over the contact sheets and did his editing and caption writing. The film photographer's intensive handling process frequently results in detailed recollections of obscure aspects of an assignment decades later. Non-photographers often comment on film photographers' incredible memories.

THE BULK OF Ted's work from 1957 to 1971 was with the NFB, although he also had a steady stream of newspaper assignments, particularly in sports and politics. He describes the early years as physically demanding, but almost always interesting and fun.

Occasionally an assignment does not require much imagination, but for the most part, when I work, my whole body is wired and I just love it. In those days, my opening line was: "Hi, I'm Ted Grant from the National Film Board in Ottawa, and I am doing a photo essay on how you build tractors. Here is my boss's card; please call him to verify." The NFB's reputation in the '60s opened doors everywhere.

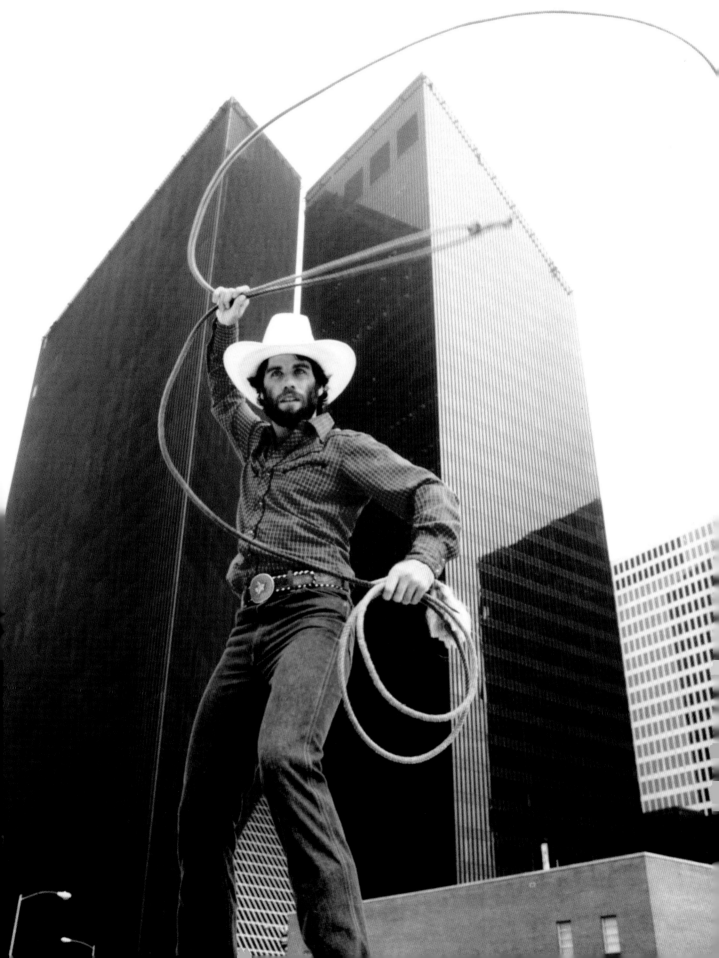

Like Pierre Gaudard, Richard Harrington, and George Hunter, a few of Ted's contemporaries in the '60s, Ted was observing and photographing average people doing everyday things. Their open-air studio spanned the full expanse of Canada itself. Of the thousands of images in the Ted Grant Special Collections in Ottawa, roughly 80 percent are of anonymous Canadians from all over the country.

It is not difficult for professionally accredited photographers to gain access to Government House or most high-level events. But you cannot be accredited to get into the places where Ted has been welcomed—far from the hobnobbing-on-Parliament-Hill sort of locations. His respectful demeanour with people gave him access to places like Africville in Halifax and the slums of Ottawa.

Ted always felt he was "lucky" with some of his best shots. When challenged, he admits he may have created some of his luck with preparation, but he still feels there was still a large degree of luck, as suggested by a phrase he uses often: "The Great Spirit was with me that day."

opposite *Africville, 1965*

Ted's many photographs of Africville capture the everyday comportment of the people who lived there. In this photo, a friendly looking resident leaning on the hood of a car gives a hint of the proximity that Ted had when he worked with people. Taken from only a few feet away, one can easily imagine the relaxed and informal rapport that existed for a moment between subject and photographer. Ted's gentle approach allowed him to observe and photograph people and show them unposed within their own comfort zone.

Africville, located on the southern shore of Halifax's Bedford Basin, was home to much of Halifax's Black population from the late nineteenth to the mid-twentieth century. When the city ordered it destroyed in the '60s, deeming it a slum, residents were evicted from their homes, some being physically removed from the area in dump trucks. The mass eviction became a symbol of racism in the city, and the land where Africville once stood was declared a National Historic Site in 2002. In 2010, the mayor of Halifax officially apologized for the eviction. Ted Grant's photos of Africville capture some of the last people to live in the neighbourhood before its destruction.

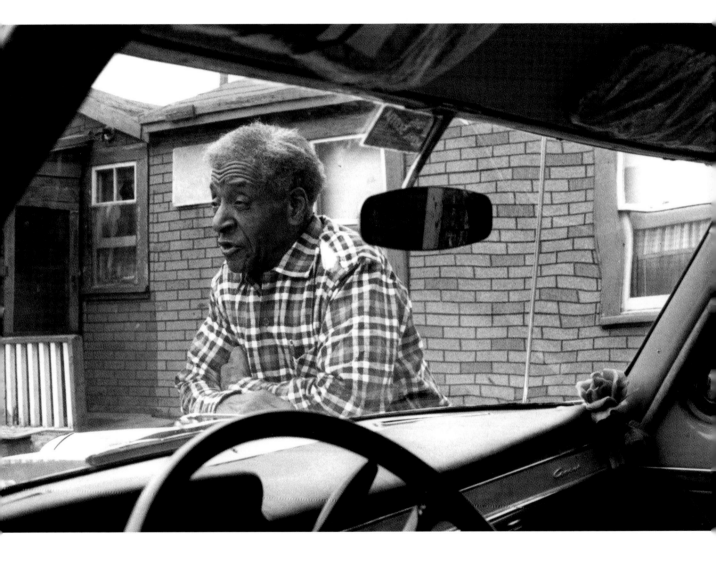

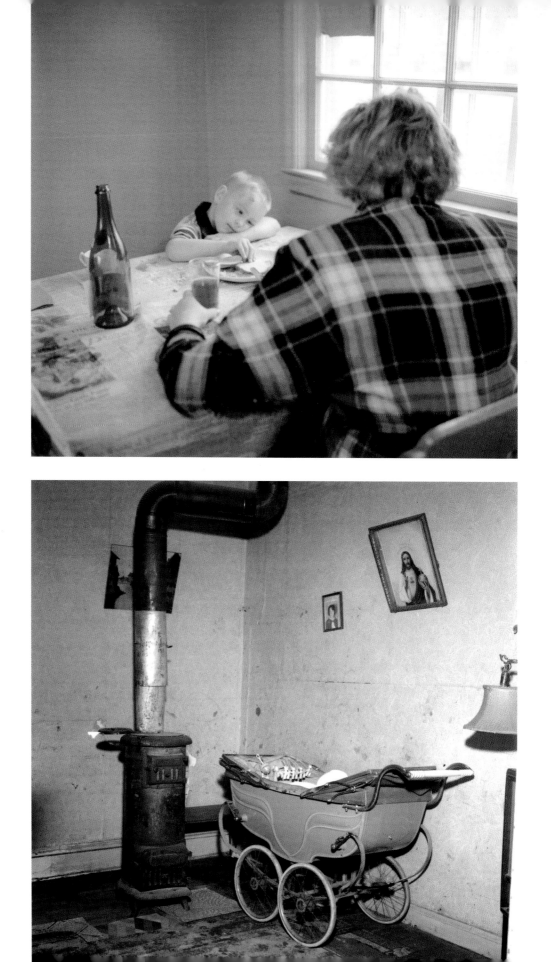

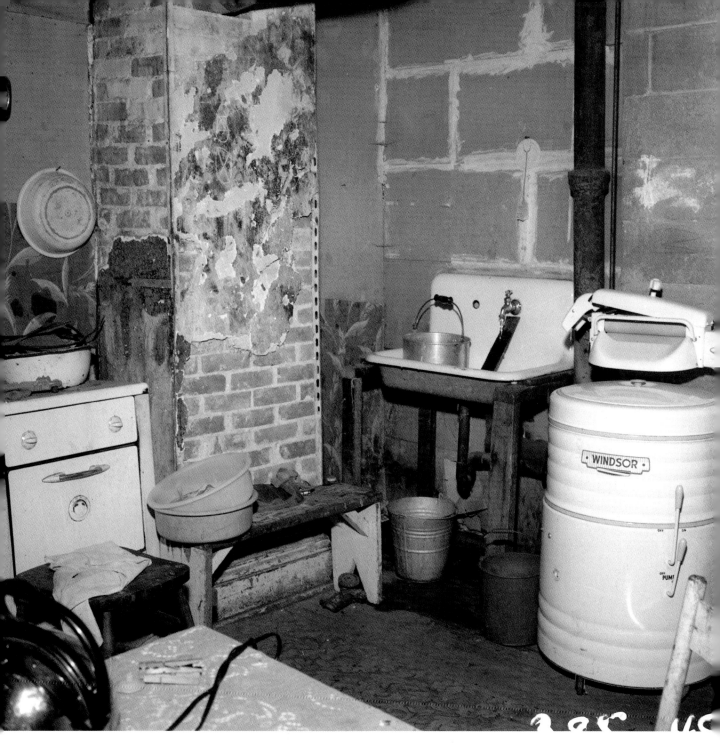

Ottawa Slums, 1953

These three pictures of a slum in Ottawa in the '50s represent the average Canadians who are part of our national memory stored in the Ted Grant Special Collections. When one considers that Ted was a stranger to this family—and a professional carrying cameras, lenses, and film—it is surprising that he was warmly welcomed into their home and invited to document the telltale signs of their poverty.

Boys' Club Haircut, 1962

When local barbers in Ottawa in the '60s volunteered an evening a month of free haircuts to a local boys' club in a neighbourhood where cash was tight for parents, Ted saw an opportunity to witness a fun story. While not necessarily a prize-winning-calibre photo, it tells a story of a specific time in our culture and of communities taking care of their own.

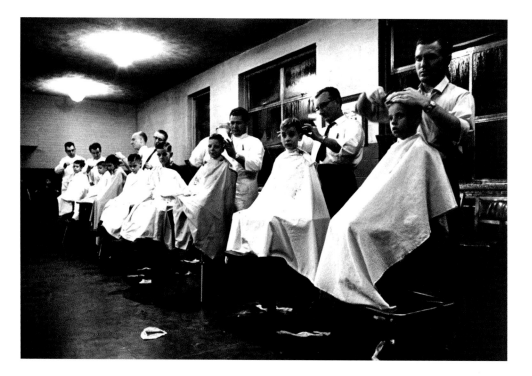

Crying Boy Haircut, 1965

In comical juxtaposition to the photo above, this image is of Ted's neighbour's young son having his first haircut. The result could not have been expected. The shot of the howling boy in the chair became iconic.

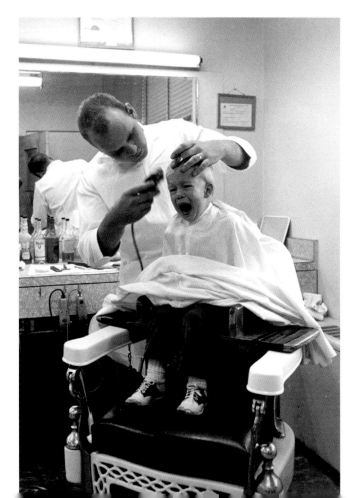

TED'S EARLY DAYS of covering local sports and then becoming the official photographer for the Ottawa Rough Riders in 1960 gave him the chance to hone the unique photography skills required by sports photographers.

> When you are shooting football with film cameras, most photographers use their right eye in the viewfinder, which means their left eye is open and they are seeing beyond the camera. In my case, I use my left eye, as my right eye doesn't see anything worthwhile.
>
> One time, I was on the sidelines, and I knew the Ottawa Rough Riders' plays ahead of time because I had photographed them in training camp through to the Grey Cup.
>
> I was kneeling down on the ground—the correct place to be when shooting on the field—and was waiting for the sweep in my direction. Unfortunately, I didn't see the ball carrier coming toward me along with three defencemen. All four collided right on top of me, leaving me on the bottom of the pile.
>
> When you get hit by four football players, and they are in the midst of a professional football game, they carry on with their game. Someone came over and reminded me that I should have kept both eyes open. He didn't realize that I had only one good eye. That was the only time I got hurt covering a sport. It was a good early lesson.

Ted was hired to shoot the Commonwealth Games in Edinburgh in 1970, and the assignment turned out to be an opportunity that led to decades of international sports coverage. Before going to international sporting events, Ted would spend about six weeks sharpening his skills with an unusual exercise. He would go to a highway near his home and use a big telephoto lens to manually focus on the licence plates of cars coming toward him at ninety kilometres an hour. His goal was to photograph the licence number as sharply as possible

and to enhance his reaction timing. Today's sophisticated automated technology makes the focusing exercise unnecessary, but Ted still feels it may have some value in sharpening reflexes.

In Ted's early sports years, there were usually four Canadian photographers hired to cover international games, and after working on several events together, the four became a high-functioning team of collaborators. Canada's Athlete Information Bureau (AIB) acted as the liaison between media and athletes. From Ted's perspective, it was an operation that worked well. The photography team documented the stories of Canadian athletes, and the media had good access.

People think covering the Olympics or any other international sports event is a cushy job. It is actually eighteen hours a day of high-adrenalin activity, and very different from sitting back and watching sports on TV. You can be crowded into a small space with two hundred to three hundred photographers, and you feel the intensity of the atmosphere. They do not generally allow tripods because there isn't room, but you are still encased in big lenses all around you.

Sometimes you don't have time to bathe every day. You don't wash your clothes unless you want to stay up when you get to your room at 2:00 a.m. and you need to get up four hours later. The intensity of aroma can be big.

You get on buses to reach event locations early in the morning and then return to the press centre, and you might have to go out again in the evening to shoot some other event. You carry a variety of long lenses along with other heavy equipment, and at the Winter Olympics, you have big coats and boots to manage as well. Winter Olympics tend to be more demanding than summer games.

Your total concentration is on getting your pictures of your athlete. There is very little down time. And you may only get three hours of sleep a day for two weeks. If you have a break in the day, lots of photographers will just lie down and sleep where they are. You experience a physical drain, until you crash after the closing ceremonies.

You come home after an exciting international event and you are still on a high—and the grass needs to be cut. And you need to do the paperwork related to the assignment. It can easily take a week before you get back to eating breakfast, lunch, and dinner at normal hours. But it feels so good not to have to be at a pool by 4:00 a.m. before all the really super shooting positions are gone. The experience takes a toll on your whole family. Irene understood the dynamic.

In 1972, Ted went to the Summer Olympics in Munich, which will forever be remembered for the hostage taking and murders of eleven members of the Israeli team. Ted captured a shot that, while beautiful, is filled with a weird irony given the tragic events of those games. Ted had not wanted to go to the start line to take pictures of a race, but he was pointedly assigned to the position by the games organizers and brusquely told to "go over there and do something."

I used a 400 mm lens, and when I looked at the diversity of size and shapes and colours of the athletes' tensed hands on the start line, I thought, "Oh, my god, look at that." Twenty years later, in the Summer Olympics, Kodak bought the shot to use as the huge entrance photograph to the Kodak lounge that was set up for photographers. That felt really good.

Munich '72 was exciting as any Olympics. I had photographed Bruce Simpson, the Canadian pole vaulter, and was pleased with one shot in particular. We were nearing the end of the games and I was working with Andy O'Brien, a sportswriter from the Montreal Star. *We were away from the Olympics on an assignment to go to Dachau, the site of the Nazi concentration camp. We spent a whole day there like any other tourists. Andy wrote his piece, I did my work, and then we returned to Munich.*

Seeing Dachau had been an emotional event. You can still feel the sadness there. Seeing those ovens was something else. We were quiet on the way back. The real shocker was walking into the main press centre and seeing everyone sitting there silently. Press centres are always hubs

continued on page 58

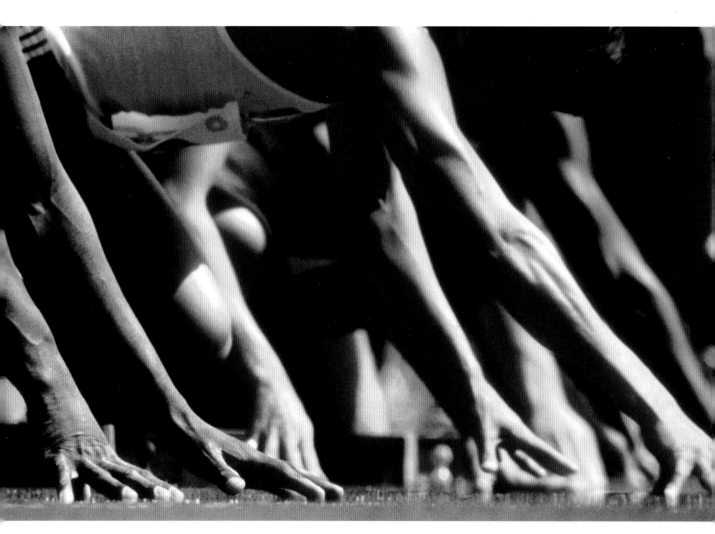

Start-Line Hands, 1972

A photo that symbolizes everything the Olympics should be—Ted took this powerful image highlighting the rich diversity of the athletes' hands at the start line just days before the Munich tragedy occurred. The ideal captured in the photograph was a galaxy away from the brutal reality of those Olympics. Ted still cries when he recalls the senseless loss of life.

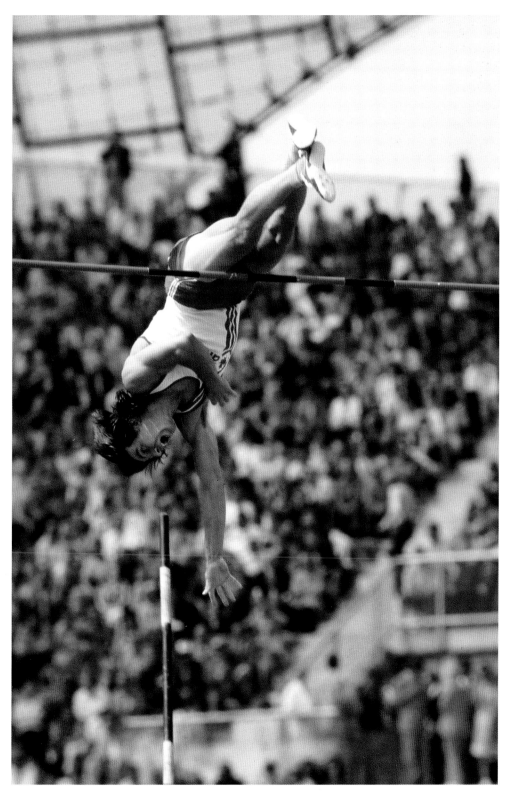

Bruce Simpson
Olympics, 1972

One of the highlights for Canadian athletes at the Munich Olympics was Bruce Simpson's fifth-place finish in the men's pole vault. Ted captures with perfect clarity the moment that Simpson surmounts the bar.

of activity. We encountered an overall powerful and eerie quiet. There was a distinct lack of music.

We had no idea that the terrorists had got the Israeli athletes. Both Andy and I were devastated. We were ten hours behind because of our Dachau assignment. The closing ceremony was just awful, and eleven beautiful athletes were dead. It is still hard for me to accept that horror.

Unlike the immediacy of reporting in the digital age, the material Ted shot for the 1972 Olympics was used by *Weekend Magazine* six weeks after the fact. Even though it was old news by then, the images extended the grief of a world being introduced to the new realities of terrorism.

In some situations, they will put fifty photographers in a designated media section, and the photographers sort out who gets the best spaces. Getting there early is important.

In 1988, on the Ben Johnson day, I was in place at 7:30 in the morning. I have my swing planned and my camera locked into the finish line when a guy comes by and tries to push me aside. There was a language barrier, but I just said, "No, get down; I have been here since 7:30." He grumbles, but he gets down.

All of a sudden as the race starts, the same guy bumps me to squeeze in, and I just took my right arm and fired my elbow out, and whoever was there left. That was the only occasion in all my years I did that sort of thing. A Japanese fellow, a man from the Philippines, and I had been there for hours and we were not about to let someone jump in front of us.

Quite frankly, I just got lucky with the shot of Ben Johnson. When I got the film back from the Kodak lab and saw what I had, I was about twelve feet off the ground. I was ecstatic. I couldn't believe I had captured that moment. The picture was scheduled right away to go on the cover of Champion *magazine—the magazine of the Canadian Olympic Association.*

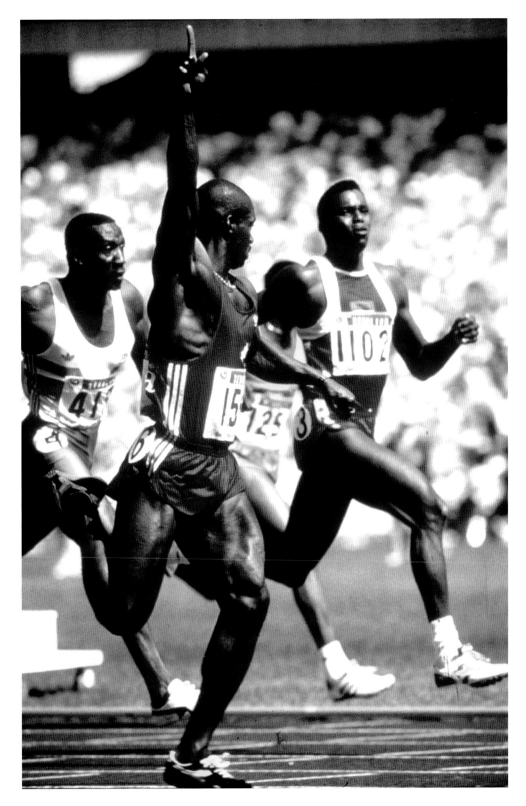

Ben Johnson 9.79 Seconds in Seoul, 1988

Every Canadian old enough to remember the 1988 Seoul Olympics cringes at the memory of sprinter Ben Johnson being stripped of his gold medal for the 100-metre sprint. Ted Grant captured the moment we all wish had lasted forever: Johnson victorious as he reaches the finish line just ahead of his archrival, American Carl Lewis.

Of course the next morning at about 6:00, I woke up to the noise coming from the media buildings. I went for breakfast in the big cafeteria and saw media people rushing all over. I heard someone say, "Ben Johnson was caught using steroids and he is on his way to the airport and going home in disgrace." All the media people were headed to the airport. I didn't believe it.

I was so disappointed. My first thought was: why would he do that? He was such a brilliant runner. Everyone figured there was more to the story, but that didn't change the outcome. I had this smashing image that went from being the perfect cover shot to an image related to shame—a high and a low in a matter of twenty-four hours. It felt like going from pinning a medal on your chest to pinning it on your butt.

But then you accept it. The shot won awards later and ultimately came to be considered a great captured moment of sport.

Ted accepted it, and so did history record it. In 1992, when the national archives published *Treasures of the National Archives of Canada*, Ted's photo of Ben Johnson was included in the publication with the following write-up:

> *The Ted Grant image of the Ben Johnson victory gesture epitomizes the photojournalist as consummate thief; stealing for posterity, a fleeting moment in time and space. With the eye of an artist, the concentration of a surgeon and the reflexes of a cat, Grant produced this quintessential portrait of what was, for at least a short time, a proud moment for Canadian sport.*

TED WENT ON to take a variety of brilliant sports shots, including that of a fallen rider at the 1971 Cali, Colombia, Pan American Games; the "swishy-pan-motion" USA speed skater at the 1988 Winter Olympics in Calgary; and the diver at the Barcelona Olympics in 1992—just to name a few.

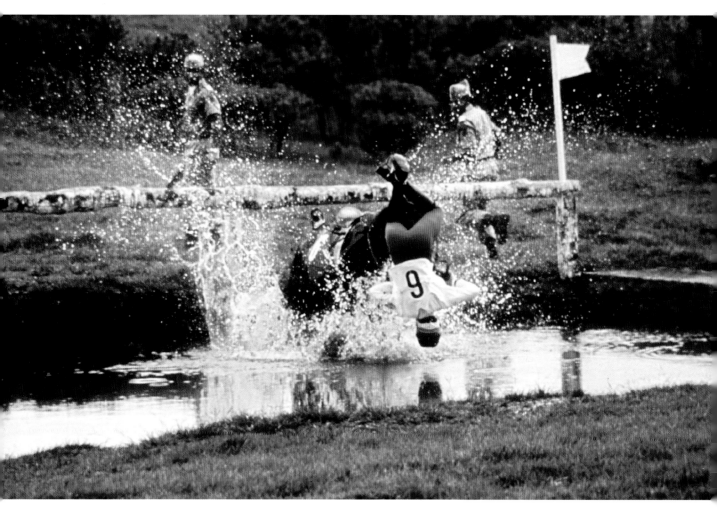

Upside-down Horse Rider in Cali, Colombia, Pan Am Games, 1971

A moment this Canadian rider would probably like to forget makes for an amazing shot. Despite this setback, Canada's equestrian team won gold that day.

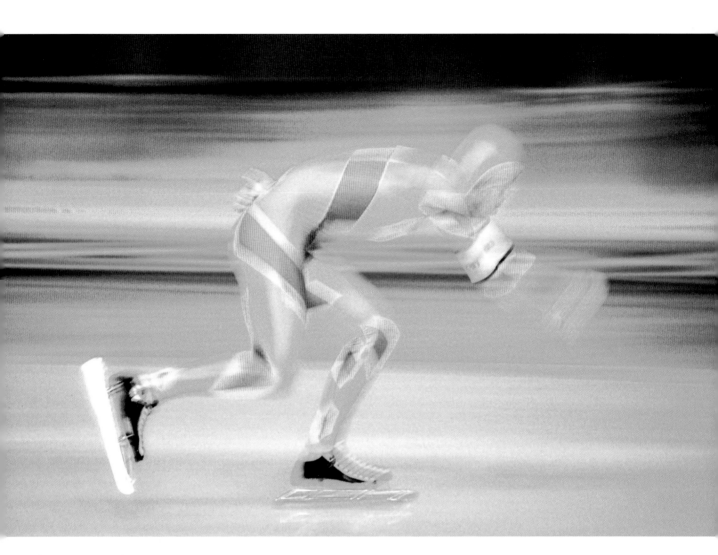

Skater Calgary Olympics, 1988

A serendipitous shot. Ted confesses to "screwing up" this photo by setting the wrong shutter speed on the camera. "I do that occasionally," he says, "like everybody else. However, sometimes it's a 'learning screw-up.'" In this case, the resulting photo looked interesting enough that Ted went on to apply the so-called swishy-pan-motion method to other photos. "I never or rarely question the opinions of others when one of my photos is referred to as a 'work of art' as this one was," he laughs.

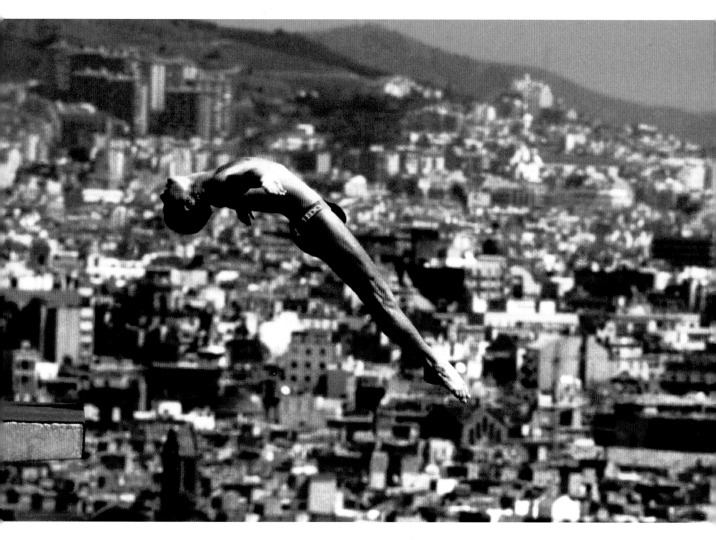

Barcelona Olympic Diver, 1992

The diving events at the Barcelona Games took place at the aquatic centre on Montjuïc Hill, one of the most beautiful aquatic venues in the world. As divers left the ten-metre tower and arched their frames against the urban sprawl below, Ted managed to include the corner of the dive platform, adding perspective to the shot.

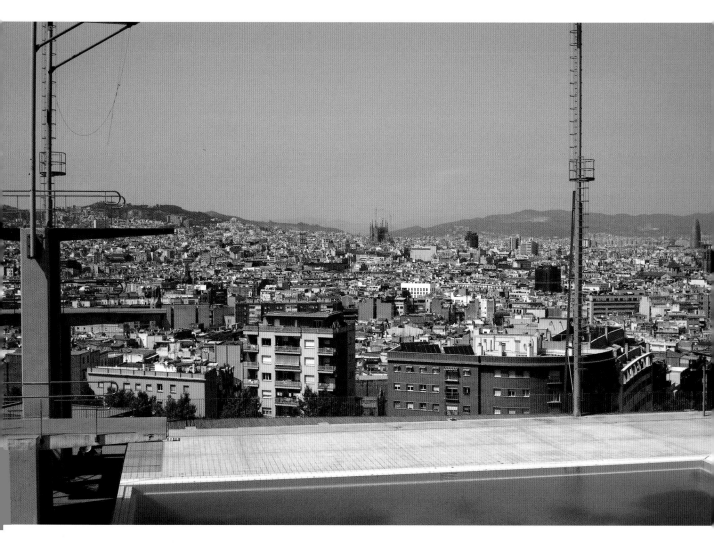

Barcelona Diving Board—Twenty Years Later, 2012

Ever the teacher, Ted returned to Barcelona twenty years after the '92 Olympics and took a shot of the diving pool where he had taken his famous diving picture. He stood in the same place and took a shot that he could use as a teaching aid for amateur photography students in his future lectures. Note Antoni Gaudí's famous cathedral on the horizon.

AT THE TOP of his game and still having lots of fun, at fifty-one years old Ted developed a problem with trigeminal neuralgia, affecting his good eye. Since he could not function on the pain medication, Dr. Brien Benoit, his neurologist in Ottawa, decided to operate for the condition and was surprised to find an aneurysm in addition to the trigeminal problem. He was amazed that Ted had made it to fifty-one.

Although Ted was lucky, the additional trauma of removing the aneurysm caused paralysis in the left side of his face. The doctor said it would eventually clear up, but Ted could not read the paper or see the TV, let alone take a picture. He thought his career had come to an end.

For the first time in his life, with very little eyesight left, he sank into a depression. He told Irene he was washed up and might as well go down to Sparks Street with a can and try to sell pencils. He figured he wasn't good for much more. Feeling sorry for himself was uncharacteristic, but Irene could see he needed a jolt to get over the slump. She wrapped up a tin can with some pencils in it, handed it to him, "Here," she said, "get at it."

Ted started to laugh. Irene's sense of humour helped him turn a corner. Gradually his sight returned to his one good eye and he was able to get back to the work he loved. The tin can and pencils still sit on the mantle in Ted's living room three decades later. Irene saved it as a reminder for Ted to keep things in perspective.

"I always figured that before I was born, the Great Spirit gave me one really good eye to compensate for the bad one," Ted muses. "As crazy as this may sound, it has always made sense to me."

3 A TASTE OF PHOTOJOURNALISM

HOW YOU SEE AND WHAT YOU FEEL VERSUS "POINT AND CLICK"

Ted Grant does not just look at birds; he thinks about their migration paths. He thinks deeply about his subject. That's what makes him a photojournalist.

JOHN OUGH
Retired Editor of the National Film Board Stills Photography Division, 2012

Some stories are told in fewer words than others. The same is true with the currency of photojournalists' stories. How many prime ministers, kings or queens, or presidents have you ever seen hop on a railing and slide down—clean, completely balanced, and arms outstretched?

The subject is clearly a man of character, a free spirit having fun—and not in bad shape either! Let's just say he doesn't look afraid of falling and embarrassing himself. For anyone who remembers the intense, confident, and playful nature of this former prime minister, the picture presents us with a symbolic facsimile of the man's life.

I like knowing that I caught this shot. And I'll tell ya, falling never even crossed his mind. In his head he was a kid. Hop on here and it'll be a great time to slide down. There was no analyzing going on. If I hadn't heard people starting to laugh I would have missed it. The laughter triggered

opposite

Pierre Trudeau, 1968

The iconic image that Ted Grant is best known for is familiar to most Canadians. The black-and-white picture of Pierre Trudeau sliding down the banister at a Liberal leadership convention in 1968 tells a full story. "This is who I am," it says.

67

me to turn around and catch three shots before Trudeau was almost on top of me.

I took the pictures with a hand-held, manually focused Leica at ASA 800. Two of the three shots were out of focus.

Photography and photojournalism are as separate from each other as a sense of smell is from a sense of taste. They are two distinct fields and senses. Of course you cannot taste anything if you have no sense of smell, just as you cannot be a photojournalist without being a skilled photographer. The two are naturally and inextricably intertwined. But you can smell things without tasting them, and you can be a photographer without being a photojournalist. There is no hard line between the two.

Just as our culture has gradually developed an appreciation for the taste of "exotic" food, after much experimentation, study, and reflection over the last century, we are similarly developing an appreciation for photojournalism. Our collective taste for the piquant flavour of a good photo story has continued to evolve with the increased accessibility of photographic technology.

The rapid growth of photojournalism in the 1950s may not seem as dramatic as it has been in the early twenty-first century with the proliferation of digital cameras, but the '50s were still pioneering years in the field given that photography in general was a much less accessible activity than it is now. There was not a camera in every home sixty years ago, and it was relatively rare to have more than a few baby pictures. For most Canadian families, the cost of developing pictures was considered an "extra," a small luxury expense. Magazine photography was seen as prestigious, and this was the prime era for the NFB stills division.

In their photo essays, NFB photojournalists in the '50s and '60s were combining their goal of telling stories about a young country with their exploration of composition and the kind of lighting understood by Rembrandt in the 1600s.

I was on the stand in court early in my career and was asked what I did for a living. When I explained that I was a photojournalist, the judge asked if that was the same as a photographer. I said, "No. I write with a camera; I take pictures that tell a story."

In a general sense, I always thought of a photojournalist as someone who was working for a magazine, and who told stories with their pictures. They didn't just do the standard, old-fashioned, front-page news shot.

One distinction of photojournalism is that a photojournalist usually exercises very little control over his or her subject. Photojournalists wait and observe and mostly photograph the world as they find life—in the moment. Lighting and composition are cornerstone aspects of good photojournalism, but preconceiving a particular outcome is not.

If I am doing a shoot on the automotive industry of Canada, I look at where they start to build the car and follow what happens to it until some-one loads it on a train to ship it across the country.

If I head to Frobisher Bay with two or three ideas to start with, I nearly always find other unexpected story ideas, mostly because I am reacting from my heart to what I see. If you are photographing anything pertaining to life that is movable on its own or may change its colour, you are shoot-ing "live," and that is part of being a photojournalist.

A photojournalist may not imagine a shot beforehand the way a highly skilled portrait photographer might. The portrait photographer will take the time to study a subject and preconceive a composition and determine the best lighting. This is generally not the case with photojournalism.

Yousuf Karsh abruptly removed a cigar from Winston Churchill's mouth to achieve an effect. He was working with a camera that was on a tripod and already focused on a subject. He could walk up to Mr. Churchill, pull the cigar away, and as the subject's expression changed Mr. Karsh squeezes a rubber ball, or whatever release he has, and the camera takes the picture.

At times I wish I had Karsh's guts so that I could get a different picture from what is appearing in front of me. But it would feel impolite for me to do that in my field, where I am often working in the comfort zone of a subject—they are

not in my studio space. I don't preconceive. I am well prepared with my equipment, and I observe and wait to be moved by something I see.

One could argue that it takes guts to go into a situation without any hint of a particular outcome.

Ted's ability and eagerness to work without preconception has been a pivotal component of his brand of photojournalism for over six decades. It is this special quality that has led to his work being exhibited in galleries such as the Canadian Museum of Contemporary Photography (CMCP) and the National Gallery of Canada, where one of the Ted Grant Special Collections is now stored.

The following simple shots are a few examples of classic photojournalism selected from among the hundreds of thousands of photos in the Ted Grant Special Collections in Ottawa.

If you know anything about football, or even if you do not, you cannot miss the contrast of victory and defeat in this 1974 image.

Ron Lancaster, 1974

Pictured here are Wayne Smith and Jim Piaskoski, members of the Ottawa Rough Riders' staunch Capital Punishment defensive unit, their backs turned on legendary quarterback Ron Lancaster.

"Two great big defensive players from the Ottawa Rough Riders had just hammered quarterback Ron Lancaster of the Saskatchewan Roughriders," recalls Ted. "I think it was the last play of the game."

Daryl Jones, a football fan, offers the following interpretation:

> *Most football pictures are action shots, reflecting a sensational catch or an outstanding defensive play. What makes this photo interesting is that it was taken after the action had ended, but it still manages to convey what happened on the previous play, as well as in the overall game.*
>
> *CFL Hall of Fame quarterback Ron Lancaster has obviously attempted to throw a pass but was under intense pressure from Ottawa's defensive line and was knocked to the ground shortly after he released the ball. Lancaster's demoralized attitude suggests that the end result of the play was an incomplete pass at or near the end of the game. These inferences arise from a few critical elements in the photo. First, it is unlikely that Lancaster would be on the ground without the ball, unless he was hit while attempting a pass (otherwise it would have been a penalty). The two Ottawa players with their backs to the camera walking away are defensive linemen (indicated by their numbers) and presumably they are the reason why Lancaster is now on the ground. Second, it was probably an incomplete pass because all of the defensive players are walking casually back to their side of the field. If the ball had been caught by either team, the play would have been still alive and the defensive players would be running to get involved.*
>
> *Lancaster's demeanour—his position, on his hands and knees and hanging his head—does not imply an injury but rather a demoralized spirit, although he may have also been feeling pain from hits he may have taken in the game. I suspect it had been a long and frustrating day for him and the Saskatchewan Roughriders.*

John Diefenbaker and Tommy Douglas Laughing, 1962

Political rivals all their lives, Conservative John Diefenbaker, Canada's thirteenth prime minister (left), and NDP leader Tommy Douglas (right) share a burst of good humour with an unnamed Scandinavian ambassador (centre) at a Rideau Hall reception. Judy LaMarsh, a Liberal MP, is barely visible in the background. The shot also makes us wonder: can we even imagine a genuine, friendly encounter with an unscripted demonstration of respectful listening and authentic enjoyment of the "other" in our current political landscape?

JOHN DIEFENBAKER WAS leader of the Progressive Conservative Party and the prime minister. Tommy Douglas was the first leader of the New Democratic Party (NDP). This shot tells us something of a historical moment with two politically opposed leaders in the foreground and a diplomat in the middle. Tommy Douglas, his head thrown back and laughing, was known for his wit and intelligence. Ted is only a few feet away and shows us a rare moment of genuine civility between the two men. This is a revealing, candid photo at a very formal event. The individuals are not remotely aware of the camera; they are engaged in their conversation and reacting to each other. The image is a long way from the "grip and grin" shots typical of such functions.

Tommy Douglas for Leader, 1961

The handmade signs at the political rally proposing "Tommy Douglas for Leader" remind us of a moment in history and allow us to witness the organized support for a leader fondly remembered as the father of Canadian medicare. Douglas facilitated a turning point for social programs in Canada, and Ted remembers him as "a wonderful chap."

**John Diefenbaker and
Baby Catherine Clark
at Stornoway Garden
Party, 1978**

Former prime minister
John Diefenbaker,
remembered for a stern
demeanour, responds to
Joe Clark and Maureen
McTeer's daughter
with uncharacteristic
joy when the little girl
suddenly surprised
everyone present by
addressing Diefenbaker
as "Grandpa."

In the above photo, Ted captured a rare moment of delight behind the usually serious face of leadership. It was not until the filming of *The Art of Observation* three decades later that Ted learned what the little girl had said to delight Diefenbaker so.

Diefenbaker had a fabulous memory. I met him in 1960 and over the next years, he always called me by my first name. "Well that was easy, Ted. Thank you very much." A month later, "Well I haven't seen you in quite a while, Ted. How are you?"

Ted began photographing Joe Clark when he became the official photographer for the Progressive Conservative Party's annual convention at Château Laurier in 1960. The

young, unknown Clark was a last-minute stand-in for a travel bureau shot Ted needed. He continued taking pictures of Clark well after the election in 1979, when, at the age of 39, Clark became the youngest prime minister in Canadian history, defeating the Liberals after sixteen years of power.

Of the prime ministers I have worked with, I was probably the closest to Joe Clark. I was called in because I seemed to have made a memorable mark in photographing Robert Stanfield, federal leader of the Conservative Party and another person I greatly admired. The next thing I knew, I was shooting on the road with the Conservatives. You never know where assignments will lead. My very quiet Leica camera allowed me into locations where I could be unobtrusive.

The three shots of the Rt. Hon. Joe Clark on the following pages also give a sense of Ted's ability and ease in very different situations. Although an interesting broad angle, it would be fairly easy to take the first shot at the public convention, but the other two images are intensely private situations that show a depth of sadness and disappointment. Ted and his camera are only a few feet away from his subjects in both cases, but the subjects do not appear to see him.

As Maureen McTeer puts it, "He is in the room, but he is not in the room. He would never violate anyone's privacy or sense of space. Ted will wait for the photograph. If you are aware of his presence, he will wait until you are not. That is a very unusual quality for a photographer. Ted was also a good friend and was always welcome into our family and our life with his camera. He is a pretty wonderful human being."

As I completed my research for this book and met with a variety of people in Ottawa and Toronto, I repeatedly heard the same story. Whether in political, bureaucratic, athletic, or medical circles, Ted consistently left an impression of being a consummate professional —and a first-rate human being.

The Ted Grant Special Collections in Ottawa contain a substantial number of photographs of of the major political parties' leadership conventions—an unusual record of

continued on page 78

Joe Clark—The Public Professional, 1979 (opposite, top); Joe Clark and Maureen McTeer, 1980 (opposite, bottom); and Joe Clark—The Private Professional, circa 1980 (above)

These three photographs of Joe Clark give a hint of the character of the public professional, shown here at a Conservative convention in Quebec City shortly before being elected Prime Minister in 1979; the sensitivity of the unmasked personal character, shown watching the federal election results with his wife the night his party was defeated in 1980; and the intensity of the private professional, shown at far right with his staff during his 1980-83 stint as Leader of the Opposition.

accomplishment and a sign of respect for a single photojournalist. Ted has made a professional point of being the first to arrive at press conferences and the last to leave. It was a steady habit that garnered payoff photographs throughout his career. One in particular was a 1961 shot taken at Government House in Ottawa at an event that was billed as a media photo op. Governor General and Madame Georges Vanier; David Ben-Gurion, prime minister of Israel; and Prime Minister Diefenbaker were lined up for the obligatory stock press photos. When the media officer advised photographers and journalists to leave at the end of the allotted time, Ted held back, as usual, with camera still ready. The other photographers had left or had turned their backs when Madame Vanier dropped her purse. Ted was the only one to catch an interesting slice of old-fashioned manners when the three gentlemen inclined to help pick up the purse. The unposed, unanticipated shot came about as Ted's reaction to circumstance. Madame Vanier picked up her purse just before Ben-Gurion could reach it.

> *You often get about three minutes to take pictures at these official events and then everyone is instructed to leave. I always stay for a moment without turning my back on the scene. If something unexpected happens, you will not have time to think; you need to be ready to react immediately. It doesn't matter what the assignment is. You never know what is going to happen.*

Who takes an award-winning photograph of the back of a visiting dignitary's head? Ted Grant. During that same visit to Ottawa in 1961, David Ben-Gurion was asked to do an inspection of the ceremonial honour guard in their full regalia. As much as it is an honour, the dull-to-some formality of the event is repeated scores of times a year in Ottawa, so a fresh take can be hard to come by. The rich composition of this candid shot is full of contrasts: short and tall, white hair and black busbies, suit and uniforms, anonymity and fame, leader and led.

"As soon as he walked by me, all I could see was the contrast of the back of his head of white fluffy hair against the backdrop of black busbies," Ted recalls.

Madame Vanier and the Dropped Purse, 1961

Who says chivalry died in the Middle Ages? Governor General Georges Vanier, Prime Minister Ben-Gurion, and Prime Minister Diefenbaker bend down to retrieve Madame Vanier's dropped purse.

*Inspection—
Ben-Gurion's Hair, 1961*

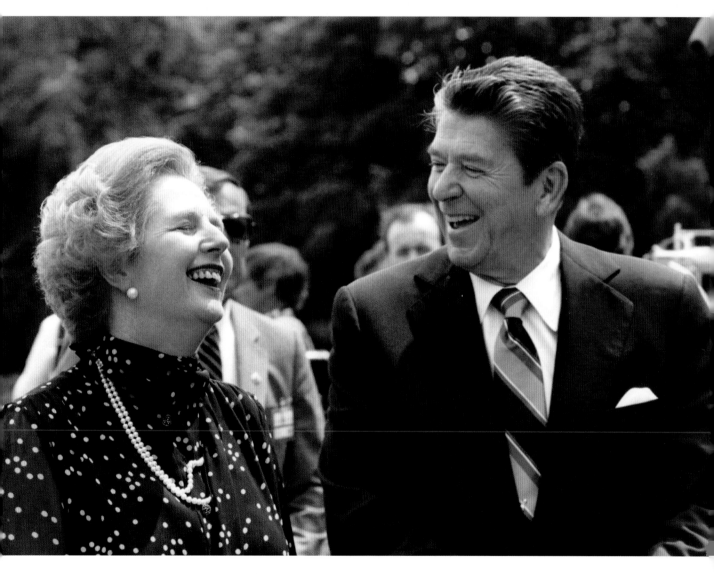

Margaret Thatcher and Ronald Reagan, 1981

Ted Grant was the official photographer at the July 1981 G7 Summit hosted by Prime Minister Pierre Trudeau at Montebello, Quebec. Great Britain's Margaret Thatcher and American president Ronald Reagan were the star attractions in a group that included leaders from Japan, France, West Germany, and Italy, and the president of the European Commission.

IN 1960, TED was tipped off that there might be a demonstration in the House of Commons. Something *might* happen in a place where demonstrations were strictly prohibited. Ted was curious. You are not allowed to take pictures in the House of Commons. You are not even allowed to take notes or bring a book or a purse into the visitors' gallery. However, there were no sophisticated security checks in those days, and Ted took his chance.

I sat in the members' gallery as a visitor. The camera was fastened on my belt around my waist. I was by myself and didn't have to worry about other people blocking my view. The demonstration took place at the end of the chamber in the public space. When I heard someone begin to sing "O Canada," I stood up right away and discreetly pulled my jacket back.

All of a sudden papers righteously flew into the air and the House of Commons protective staff rushed to the people who had thrown them. I got three shots. And as soon as I did that, I got up to leave. I saw a security guard and I asked, "What is that all about?" He ushered me along, saying there was nothing going on and would I please keep moving. I was out of the building quicker than you can imagine.

It was too late in the day for eastern newspaper coverage but my partner called the Vancouver Sun, *and they ran my shot later the same day. What I didn't know was that the sergeant-at-arms was furious that the picture had been taken under his watch. However, there was no credit line on the photo and I was not identified.*

The story gets better. Nothing was ever done because nobody knew who took the picture. One day a couple of years later I had to get permission to take a photo of an MP in the chamber of the House. I walk into the sergeant-at-arms' office, and he says: "I have been looking for you for about two years. You are the one who took the photo when there was a demonstration."

He knew all the details and said he had a good mind to take my press ID away. I asked him not to do that as I needed to take a lot of

pictures on Parliament Hill. Then I grovelled a little. I told him that for the last two years I had been fearing this moment (I hadn't really), and I figured that the long spell of fear had been my penance. He was a tough character, but he had this great big smile and said under those circumstances I was forgiven, but if I ever did it again, I would never get back inside the Parliament buildings. I pushed my luck and had to be a bit wimpy, but as far as I know nobody has ever shot something like this in the House of Commons.

House of Commons—Flying Paper, 1960

Sometimes you have to bend a few rules to get the right shot. Ted sneaks a photo of a demonstration in the House of Commons.

House of Commons—
John F. Kennedy, 1961

On a more solemn occasion, the fully packed House of Commons was filled with appropriate decorum when US president John F. Kennedy visited as guest speaker—another historic moment captured by Ted.

Windy, Wintry Ottawa Day—
Bundled Old Man, 1962

A look at Parliament in Ottawa and a nearby monument obscured by a windy snowdrift give us a chilly Canadian winter shot. We hardly notice the tiny, bent, swaddled old man directly in front of the Peace Tower, but he is what inspired Ted to take the shot.

TED GRANT

84

Mountbatten at the Calgary Stampede, 1967

Lord Mountbatten, the great-grandson of Queen Victoria, was a guest of honour and sitting next to his daughter at the Calgary Stampede in 1967. Ted was in Alberta on a ranching assignment and stopped in Calgary to cover the event. At first, he did not know what the audience was reacting to, but the sneers told him something bad had happened—a chuckwagon had just crashed. "I looked around and realized I couldn't get a decent picture of the crash," Ted recalls, "so I chose to focus on the spectators."

In 1964, Ted was assigned by the NFB to do a feature series of photo essays related to economic development in Canada.

I was walking around the streets of downtown Toronto and passed by the Rolls-Royce store and decided to go in. As soon as I said I was working on a project for the NFB, they warmly welcomed me to take photographs.

A couple was in the showroom looking to buy a car. I walk around and noticed the Rolls-Royce insignia reflected in the hood of the car next to an eager salesman and his customers. I thought, "Oh, my god. Look at that." It wasn't until later that I noticed the reflection of the crane in the hood— also a standard symbol of economic growth. It was a lucky extra that fit the theme of the NFB assignment.

Rolls-Royce, 1964

The Canadian icebreaker *D'Iberville* was enclosed in ice in the High Arctic.

All of a sudden they pulled the ladder up when I was out on the ice. The ship engines started and it scared me. I ran back, and the captain was not a happy camper because I had wandered too far from the ship without telling anyone. Be that as it may, I survived. The captain thoroughly thrashed me verbally. I had been preoccupied with wondering how the ship would look from a distance.

D'Iberville *Icebreaker in the High Arctic, 1957*

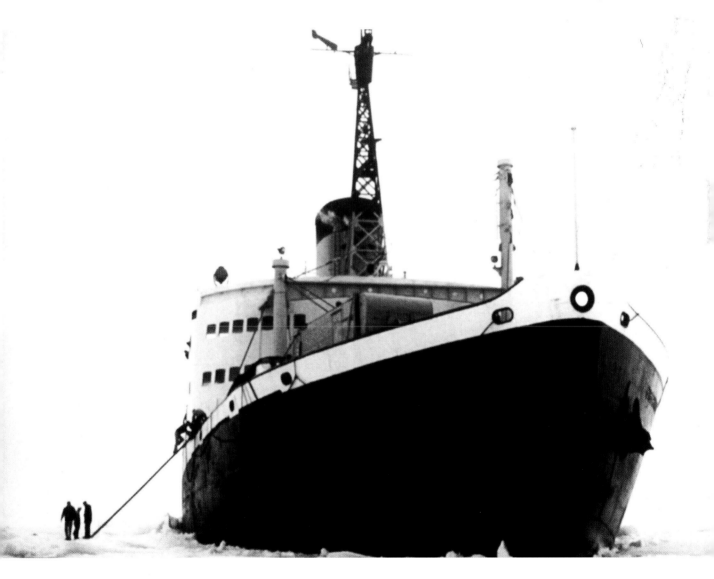

The NFB sent Ted to Vancouver's Chinatown for two weeks in 1963. His assignment was to capture images from all aspects of the community while interviewing a variety of people. The photo essays were created for use in presentations at Expo 67 in Montreal. Ted spent sixteen-hour days wandering in the neighbourhood. When he switched a camera one day from a Leica to a Hasselblad, one of the drivers at a taxi stand smiled and called out, "Hey, you changed cameras!" It seems the community was very aware of his presence and observing him as well.

One of the recurring themes in the thousands of Chinatown shots taken in homes, in schools, and out in the community is the caring natures of the subjects, as exemplified

Chinatown—
Elderly Gentleman
and Pet Bird, 1963

Chinatown—
Studious Girls, 1963

Chinatown—
Dad Feeding Son, 1963

these three images. The elderly man joyfully cares for his prized pet, the young girls care deeply about learning, and the father feeds and cares lovingly for his young son. This father and child scene in particular was not a common image of males in the wider Canadian landscape of the 1960s.

Before I could go into the Chinese homes and their shops in Chinatown, I asked to see the matriarch of the family I was visiting, to make sure she was comfortable with my presence. I was moved by an incredible and gentle respect for the elders. The art of this kind of assignment is way more rewarding to me than the fees I earned. It never felt like work to me. Photojournalism is about responding to a feeling.

The man, fondly caring for his pet bird, lived in a senior's home in Chinatown. He spoke to the bird in Cantonese. The gentleman would say something and the bird would chirp back to him. Or that's what I assumed, as it seemed each time he spoke to the canary it would respond with a bunch of chirping.

Look at the little girl with her finger on her chin. I just sat silently and watched them. I am not there to talk to anyone. When you are on a shoot, your eyes are open and your mouth is shut. The thoughtful finger on her chin was the motivator for this picture.

If you see the father feeding the child soup, it may not seem like much; but as I documented their family life, it was the essence of a scene that repeated in so many different ways and spoke to their closeness.

Young Canadians Making Music in the Park in Victoria, BC, 1962

A carefree young couple relax on the city hall grounds in BC's provincial capital. They were playing music and just enjoying themselves on a sunny day—very casual, but prepared for the west coast weather with their umbrella nearby.

right **Stanley Park Flower Power, 1963**

An early snapshot of what would, later that decade, develop into a full-blown social revolution. This "love-in" at Stanley Park in Vancouver had a peaceful, relaxed atmosphere. "People were rolling their joints," Ted remembers. "No one was causing problems. Everyone was enjoying the wonderful day."

below **Molson Beer Truck and Hitchhiker, 1967**

On a cold and lonely highway, Ted managed to capture every hitchhiker's dream—to be picked up by a Molson beer truck.

Moscow—Young Military Men in Red Square, 1992 (right); Moscow Streets—Elderly Cleaning Woman, 1992 (below)

On assignment in Moscow shortly after the dissolution of the Soviet Union, Ted captured the visual contrast between a hard-working elderly woman cleaning the streets in front of St. Basil's Cathedral and a young military honour guard near Lenin's Tomb in Red Square.

right **Busy Hands in Conversation in Rome, 1967**

An Italian couple is busy in conversation, hands flying, as they walk down a street in Rome. They are not paying attention to what is going on around them; they are ensconced in a private, unscripted moment, captured by an observant stranger.

below **Oktoberfest German Barmaid, 1962**

A young barmaid at the Oktoberfest celebration in Munich in 1962 is nursing customers with her skillful ease in toting four large, heavy steins of beer at once. Is she also a nursing mother?

above **Stockholm Kids Playing Hockey, 1969**

No, this is not Montreal or Toronto. What appears to be a typical Canadian city scene of children playing street hockey in the winter is in fact a street in Stockholm, Sweden. Ted was travelling with Canada's national hockey team covering the 1969 World Championships. "These kids reminded me of home, where children would play on the street with *Life* magazines strapped to their legs as shin guards, yelling out 'car' when they needed to stop and pay attention to traffic."

left **Elderly Students Creating Art in Victoria, BC, 2002**

Ted captures the focus of senior citizens thoughtfully creating art. With this shot, you cannot help but wonder, again, how does he so unobtrusively get into these private moments?

Bee Shadow, 2003

It can't be easy to photograph the perfect shadow of a bumblebee in flight. "An image of the shadow of a hovering bee on a flower is a purely lucky light shot," Ted says. "And anyone who tells you otherwise is lying."

TED WAS ALWAYS aware of the importance of his job and never tired of going on assignments and discovering new subjects.

I was always proud to be a newspaper photographer in my early days. That, to me, was a mark of something special. Most of the super-fine Canadian newspaper photographers I knew felt the same way. But my work evolved over time and as a photojournalist, my scope quite naturally continued to grow out of my need to satisfy my own curiosity.

When I was shooting assignments for Weekend Magazine, Star Weekly, *the* Toronto Star, Maclean's, *the NFB, the Department of Industry, Trade and Commerce, etc., I might be shooting absolutely anything. I have been lucky and am well aware of that. I have often been in the right place at the right time, met the right people, and have had wonderful assignments. In this work, you are privileged to be "seeing" all the time.*

4 MARTHA

FINE ART OR "PHOTOJOURNALISM AT ITS FINEST"?

It is not enough to create more and more images with our billions of digital cameras. We need to think and reflect on our photos.

RON POLING
Retired Photojournalist, Canadian Press, 2012

R on Poling got his first Brownie Hawkeye when he was eleven years old. He joined a camera club in high school and considered himself a "very interested amateur" by the time he was in his second year at Carleton University in Ottawa.

A job opportunity came up with the university photographer, and Poling decided to leave his full-time studies and go to work. He figured he could finish his degree at night and started off as the photographer's assistant—not to be confused with an assistant photographer, a little higher up the ladder.

But his plan changed abruptly when he noticed a new listing in the 1972 course catalogue. Photojournalism was being offered with a guy by the name of Ted Grant. Poling signed up and found himself back in school and working at the same time.

"The right teacher came along at a perfect time in my life," he remembers. "Ted had never taught before, and on the first night he shows up, nervous as hell. He stood in front

opposite

Martha in Green, 1969

Ted's photos of Martha, the young woman Ted worked with during a photography workshop in New York, made a lasting impression on Ron Poling, one of Ted's first students at Carleton University, who went on to become a successful photojournalist in his own right.

99

of the class of twenty-five third-year students and forgot to introduce himself. He started right into the lecture using two Leica projectors set up to do 'fade and dissolve' images into each other. That was pretty cool stuff at the time."

Poling and the rest of the students sat engrossed by the well-prepared series of riveting images interlaced with fascinating stories. Ted was a rare combination of entertaining raconteur and natural teacher, as well as being highly skilled at his art.

Poling and his friends invited Ted to the bar after class, and razzed him about not introducing himself. "By the way, you are Ted Grant aren't you?" they chided. "You never did say in class."

That night Poling decided he was going to be a photojournalist and planned to learn as much as possible from Ted. "I never missed a single class," he acknowledged forty years later.

Ted had been approached to teach the class at Carleton by Joe Scanlon, a well-known Canadian reporter, shortly after the Munich Olympics. It was a gig that lasted almost nine years. Ted proposed to the large class that it might be fun if they divided into two groups to have a friendly competition that would simulate the competitive business environment they would soon enter. Each semester, the "Hot Shots" and the "Charlie Browns" set off to outdo each other.

"The world of professional photography in Canada is small and insular, and everybody knows everybody in this business," says Poling. "You can pretty well pick up the phone and call anyone and they know Ted Grant. Ted's students are scattered all through the country. To this day I run into people who were at Carleton and who have gone on to become the lead people in the industry. All of them remember Ted's class and will say, 'I was in his second class; I was a Charlie Brown.'"

Ted created his own curriculum based on the way he had learned his skill. For one assignment, he had students take the camera and focus as close as they could possibly focus a 50 mm lens. They had to take one frame of thirty-six different people—and make them all sharp. Ted had several technical objectives, but mainly the exercise was designed to help the students develop confidence and get over their fears about approaching different subjects.

Poling still has his contact sheet from that first assignment.

"Let's face it. Every picture has been done before. We are just doing them in our own way based on whatever impulses come from the back of our head," he says.

Ted told the students to always, always walk around the subject to understand how it will look from a different angle.

"I photographed Sophia Loren at an interview in Toronto in my early years," Poling remembers. "She was the consummate professional. She placed herself precisely; knew exactly where to stand and look, and where the light would be on her face to accentuate her cheeks. In spite of being told where to stand, I started moving around her, as Ted had taught us. She stops in the middle of the interview and says, 'Does it look nice from over there?' and I said, 'Well, no, not really, not as good as over there.' And she says, 'I thought so.'

"That was the only time Ted's advice did not pan out for me," Poling laughs.

The recently retired Poling, a highly successful photojournalist in his own right who spent the last sixteen years of his career heading up the award-winning Photo Picture Services for Canadian Press and who now sits on the Board of Governors of the National Newspaper Awards, becomes animated when recounting Ted's impact on his career.

"Canadian photography is very young," says Poling. "Although we do go way back into the 1880s when some amazing photos were taken, the craft wasn't very sophisticated in the 1950s. If you look at images from 1949 and compare them to what Ted did, you will see that he was way ahead of the pack. Ted was one of the first newspaper photographers using 35 mm—the camera that Irene gave him. He was breaking ground in Canada."

Poling compares Ted to "the guys from the golden age—the Eisenstaedts and the Robert Capas. They weren't doing just the down-and-dirty newspaper photographs. A lot of that wasn't great; it was really rude photography, particularly in the early days when the papers were not buying the latest equipment. Ted was a great experimenter with a curious mind. Part of his contribution to photojournalism is that he was experimenting early on. He was shooting with a 400 mm long lens with a squeeze grip that you could focus while you squeeze. He used it in the sensational picture of the upside down horse rider in Cali, Colombia." (See page 61.)

"Ted was creating his own brand of photojournalism. He had the ability to get the most out of a situation. He was all about eyes and light and capturing mood. When I studied his work and tried to figure out why his work looked so nice, I realized that it was because he was shooting from the dark side or the shadow side. He was using side-back lighting. And he

used the low light quality that glows with black-and-white film. He liked to shoot low light and was always pushing the limit. If you look at some of his cowboy shots in the bunkhouse, you can see the motion. He is shooting at one-fifteenth or one-eighth of a second. When he started shooting and developing colour, his exposures were perfect. He exposed to give maximum saturation. His images were nicely backlit. He wasn't afraid to have a dark frame and a picture full of ambience. He was one steady guy. He could hold that camera so still."

Poling's admiration for his former teacher knows no bounds, and he has clearly thought about what sets Ted apart from the rest.

"His pictures are distinctly 'Ted Grant' pictures. He does it his way; often he sees things differently than others and has never been afraid of failing. When you are doing a paid assignment and you are shooting one-fifteenth of a second, it takes chutzpa. They say 'no guts, no glory.' Ted has lots of both. He takes pictures and risks, and that is why his pictures look different.

"Ted was the ultimate goodwill Canadian ambassador at Carleton. He told us: 'When you go abroad, remember you are representing your country—don't be the ugly Canadian.' I have a feeling for what Ted Grant is, but it is hard to bring up all the stories that prove it. I just know it. One of the most memorable classes in that first year was a photojournalism story about Martha."

Ted typically uses one of his Martha shots in his annual presentations for the Leica members in Boston or for camera clubs around the country, but Poling advised me to track down the original full presentation Ted gave to his Carleton students in the '70s.

"You have to see it," Poling insisted, a couple of times. "The series on Martha is photojournalism at its finest."

In 1969, a conglomerate of American magazines selected a number of North American photographers to attend a colour workshop in New York City. They invited twenty-eight of us, and seeing as how we were a small contingent, the only other Canadian and I conspired to kick ass and shoot everybody else's buns off.

The instructors were mainly from National Geographic, Life, and Look magazines. The group leader of my team was Phil Harrington, an elite staff

photographer at Look. *Phil assigned me to work with Martha, a young actress on Broadway who had been in the early staging of* Hair. *She was about twenty-five years old and lived in a third-floor cold-water walk-up on the Lower East Side of Manhattan.*

I was wondering how Irene was going to feel about the young actress I would be hanging out with for the next few days. We had decided to turn my workshop in New York City into a bit of a holiday, and Irene was happily touristing around during the day while I was busy with the program. I first met Martha at our hotel and took her for coffee to talk about my assignment. She had just come from an audition for a role in a play and she was wearing a flamboyant, green, blousy Ali Baba slacks outfit.

She wasn't too happy about the audition and just as we sit down in the restaurant, she blurts out a string of expletives—really loud. I had never heard anyone talk like that before and I felt like crawling under the table. People

**Martha Chatting
with Neighbour, 1969**

were looking around to see who was being so obnoxious. I was totally cringing, but the interesting thing was, as soon as she realized my reaction, her immediate comeback was "Oh, I'm sorry. You Canadians aren't like us Americans in using language; I'll try to be more careful when we're out."

We established that she would just go about her business and I would accompany her and take pictures. As we walked along, she stopped to talk to an old fellow in her neighbourhood about four doors from her flat. So I shot it.

A little later, with the camera preset to manual, Martha was dead

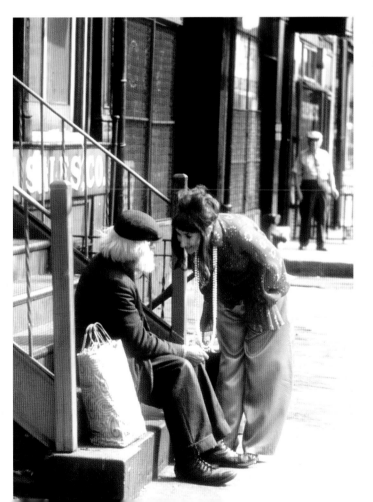

centre and I focused, tripped the shutter and completely turned the camera—hand held. I captured an interesting effect with her face at centre and everything else swirling. I don't have a clue how this worked so well. I have never gotten another one quite as perfect when I tried to replicate the spiral effect.

Martha invited me into her flat where she lived with her roommate, who, she made a point of saying, was not her lover. They just shared the rent. She welcomed me to sit down while she went into her room to get changed. The phone rings and she answers it half-dressed. So I am taking pictures and it is really no different than taking pictures of a woman in a bikini. Then she heads off and goes to the bathroom. All of a sudden I hear, "Ted, oh Ted, why don't you come in here and take some pictures?"

It was the first time in my life that I would take pictures of a naked woman, and I knew this would definitely be hard to explain to Irene. So I go into the bathroom and she is in the tub covered with bubbles. There was nothing embarrassing about it. She might as well have been clothed. She knew enough not to carry things too far.

One of the goals of the workshop was to learn how to use different kinds of colour film. I was experimenting with two types. I was using tungsten light balanced film, where the colours are presented more accurately than with some other films. In this shot, the soap looks white and the bubbles look white, whereas in some other shots, you see a bit of an orangey effect. It can become distractingly orange, though, if not balanced. The other was daylight film under incandescent light.

Anyway, Martha was playing with the bubbles and giving me plenty of opportunity to shoot. I left the room when I had enough material and went back and sat in the living room. The next thing I know she calls me into her bedroom, which is just a mattress and blankets on the floor near a dresser. She is standing naked and brushing her hair. Instead of shooting without any filters, I notice a sheer curtain hanging by the door and put the curtain over the lens to give a different, softer feeling to the photo.

Next she had to go out to a shop where they sold Broadway musical costumes. She knew the owners and told them I was doing some pictures for a Canadian magazine. She put a yellow outfit on and stood in front of the mirror. Without any flash or extra lighting, I shot her and her reflection.

At the end of each day of the workshop, we handed in our film to be developed overnight. The next morning we were given our package of images. We had to do a quick edit, pick a few images, and the group leader did a critique. I was telling classmates about my subject taking her clothes off, and what it felt like to meet up with Irene at the end of the day and explain that I had been taking pictures of a naked woman in the bathtub. Everyone in the workshop thought the story was hysterical.

It is not every day that you find yourself in a strange city with a naked woman in front of you, ready to be photographed. It may not seem like much now, but, it was in 1969!

Bubble Bath at Her Apartment, 1969

right *New Costume, 1969*

left *Getting Ready to Go Out, 1969*

Every time I turned around, Martha was doing something interesting. The second day we went to visit her ex-boyfriend and his new girlfriend. Everyone was sitting on the floor and I was shooting while they visited. All of a sudden we hear what sounds like a couple of gunshots. No one moves. It is obviously not an uncommon occurrence.

There is a knock and three rough-looking guys from next door come tell us that someone has just tried to rob them. I am sitting there on the floor taking pictures and Martha, and the guys are talking about drugs. I start getting worried about getting arrested if police show up. That was a scary moment. There was a harsh negativity in the air.

Another shot, which I refer to as "Two Faces of Martha," is a good example of why it is important these days, with digital cameras, not to delete photos until you have had a good chance to review them on a larger screen. I had no idea what I had with this image until it was developed later. There is always an element of something happening when you are taking pictures that you might not see until you do your edits later.

Relaxing with Friends, 1969

As I tripped the shutter, the exposure may have been one-eighteenth of a second and it produced a shot that reminded me of the contrast between Martha's public persona and the gentle, sweet person she was to her friends and neighbours and the local neighbourhood cat.

We did some outdoor work on the New York City streets and headed back to her apartment. Her roommate wasn't feeling well, so the two of them lit up a hash pipe and showed no hesitation about smoking in front of me.

Martha passes me the pipe and says, "Here, Ted, try it." I explained that I wasn't a smoker and it would likely not work on me. She said, "Just draw in and fill up your lungs and do that six or seven times."

While I was crawling around on the floor later I got some interesting shots. I took one picture from under the chair, with her roommate's legs framing the picture. Of course I was higher than a kite, and it felt strange to work that way.

I had a client who wanted an impressionistic picture of what a person who was smoking hash would look like and they were happy with the one of Martha.

After day two, Irene met Martha and they hit it off like buddies, as women often do.

left *Smoking Some Hash, 1969*

right *Stoned Photographer, 1969*

I wanted an image showing where Martha lived in New York and decided to get an external shot of her apartment from the fire escape. When I climbed out, Martha leaned out through the window with a big smile and told me that the fire escape had been condemned the year before. And then she had a good mischievous laugh.

Looking out, 1969

After the final day of shooting, I went back to the workshop location to have my work critiqued by the group leader. Everyone enjoyed hearing about Martha. At the end of the course we had a celebration of images and a lunch party. The other twenty-nine photographers wanted to meet Martha as a special guest. The organizers agreed and invited Martha and arranged to have her picked up to come to the party.

When all of our images were shown on the final evening of the workshop, mine was the last presentation and there was a rousing round of applause for Martha. Over the course of three days, the other photographers came to see her as a rich, multidimensional character and not just a naked woman. More of my shots were presented than anyone else's. I am not bragging, but because of the subject, they were more interesting and storied and more full of learning opportunities. Of course, Martha was really pleased.

It was an interesting and challenging exercise—both photographically and mentally—to photograph and capture a slice of a person's life. I focused on the whole of who she was. Spending several days with one subject was an incredible learning experience for me as a human being and also as a photojournalist. It offered a bit of an opportunity to get beyond the brash and superficial façade that most of us present and see in others.

Irene took the whole thing with a sense of humour because she knew how embarrassed I was at times. She thought it was funny.

Later that year, based on the success of the Martha series, National Geographic *in Washington offered me a few assignments, nothing super significant, but I felt some measure of recognition of my work.*

Martha Relaxing with
Her Roommate, 1969

IS MARTHA ART? Is photojournalism art?

"I am not the type of person who philosophizes over pictures," says Ron Poling. "I am a straight realist. You either told the story or you didn't tell the story. You had an artistic component to it, you composed it properly, you lit it properly, and when you put it together, it worked or it didn't.

"Even now, forty years later, I can visualize the details of hundreds of Ted's well-crafted pictures. Ted has had a huge impact on Canadian photojournalism. Part of his being a great photographer is that he has a wonderful personality. He is one of the nicest people you could ever want to meet. He is ethical, he understands people, and he knows how to tell stories with his pictures. He is an incredible teacher and a great mentor. These are just a few of the reasons he is an honorary lifetime member of the National Press Photographers Association."

"There is no question," Poling concludes. "Ted's photojournalism is beautiful art and it will stand the test of time. His humanity comes through in his pictures. And we are the richer for it. He is an important pioneer of modern photojournalism, whose photography, teaching, and example has inspired so many."

right *Close-up, 1969*

left *Looking Out on NYC, 1969*

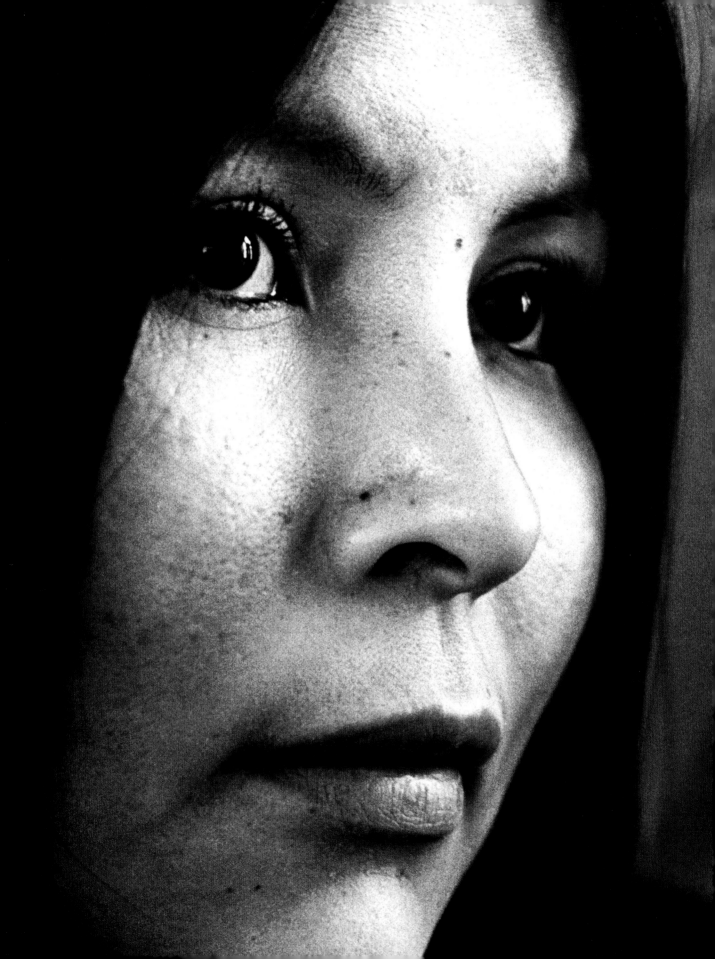

5 NOT A POSED PORTRAIT

BUT IT SURE LOOKS LIKE ONE

Since Yousuf Karsh died in 2002, Ted Grant is generally recognized as Canada's greatest living photographer.

PHOTOGRAPHER'S FORUM, 2004

In 1999, Ted Grant and Yousuf Karsh, the famous and accomplished portrait photographer, each received a prestigious Lifetime Achievement Award from the Canadian Association of Photographers and Illustrators in Communications (CAPIC). The two men were honoured for their individual brands of photography.

"It was a proud moment to be recognized along with Yousuf Karsh," says Ted. "I believe he was *the* greatest Canadian photographer, and it felt like winning an Oscar to be celebrated in his company."

Years earlier, Ted received a Karsh Award for the best black-and-white photo in the photojournalism category. The 1972 prize-winning image of a young woman from the Northwest Territories could easily be mistaken for studio portrait work; however, as is typical of most of Ted's work, it was unposed.

As Ted took pictures of the young woman and her co-workers, she asked him to go with her to visit her grandmother in Fort Rae the next day. Courtesy of Ted's signature

opposite

Karsh Winner—Indian Princess, 1969

Ted met the subject of this award-winning shot while he was working on an NFB assignment related to gas and oil explorations in the Northwest Territories. This young woman was one of the people working in a government office and was introduced to Ted as an "Indian Princess."

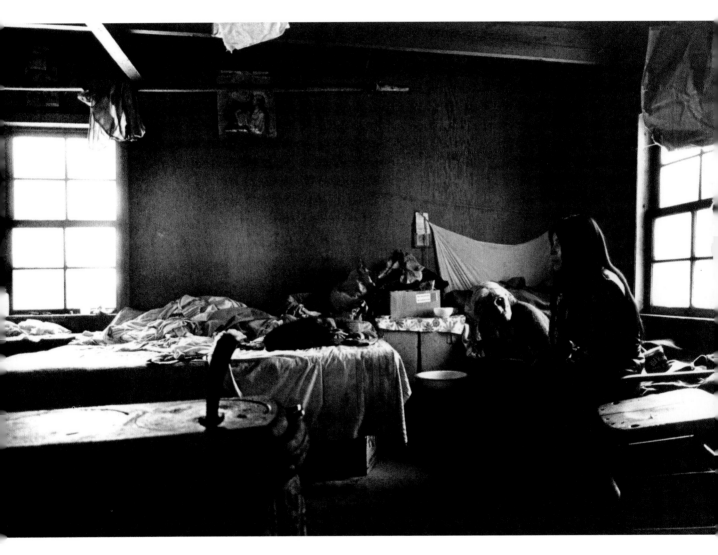

Not a Karsh Winner—Princess with Grandmother, 1969

While the close-up, prize-winning image is spectacular in its standard and familiar form, this picture of the same young woman sitting beside her grandmother offers a different, fuller story. Although both are beautiful images, this one offers insight into the young woman's life. From the wide-angle shot, we get a sense of relationship—to her surroundings, her home life, and her beloved grandmother.

style, the moment we are invited to share is a natural and private one. Unlike the portrait-style image of the "Indian Princess" that could only draw a narrow range of interpretations, a dozen different viewers would likely find a dozen different interpretations of this shot.

The white man from the nation's capital, a complete stranger, is right there in the room with the two women—only a few feet away from them. While detached, in the sense that he is not directing or controlling a photo shoot, Ted is also very attached in his role of silently and respectfully observing and photographing. His informal accreditation is a demonstrated respectful approach to the people beyond his lens. We can guess that the young woman had to trust this stranger to bring him into grandmother's home.

Ted may have been formally awarded for the more traditional, portrait-like shot of the "Indian Princess," but the lesser-known image of the young woman and her grandmother is designated as a "treasure of the country," safely stored in state-of-the-art preservation vaults in the National Archives of Canada.

Most of the photographs in this chapter were taken when the subjects were not aware they were being photographed. The selection gives a sense that an unposed photograph can often produce a superior likeness compared to one taken under the pressures and formality of studio lights.

> The best way to make an informal portrait is to encourage your subject to go about their business. You will find your pictures while observing that activity—where people are often more at ease in their own familiar surroundings. Directing a subject makes them stop living and start posing —which is unnatural.

Because of his reluctance to pose subjects, some of his archived shots may be technically imperfect—even out of focus or underexposed—but the thousands of images are original and rich in content.

Ted's son Scott Grant, a nationally recognized sports photographer in his own right, offers a biased yet valid assessment of his father's body of work: "There are great photographers in every field, but I don't think there are too many great photographers that are great in every field—as my dad has been."

Like the first photo of the young woman from the Northwest Territories, the following photo of Israel's first prime minister, David Ben-Gurion, has the appearance of a classic, carefully posed portrait. In fact, it is often mistaken for a Karsh portrait. The picture was actually taken during a media scrum while four journalists asked Ben-Gurion questions.

I knew I was well positioned and had the right light, so I just stood near the scrum and waited and watched his eyes as the questions were being asked. He is listening intently. That is all I am watching.

We hear with our ears, but we listen with our eyes. Our eyes change dramatically when we are thinking.

I manually focused, waited for the right moment, and then took that shot with a little 35 mm camera.

Ted relies on his intuition to be able to recognize the "decisive moment," a term coined by photojournalist Henri Cartier-Bresson in 1952. The fleeting opportunity occurs when all elements of a perfect photo seem to line up. Available light, colour, action, shadow, and expression combine to capture a moment of history—the primary destination for a photojournalist. In this case, the sheer determination and intelligence of Prime Minister Ben-Gurion shines as the "truth-telling historical moment" for Ted. You rarely get that effect in a standard portrait.

If you sit back and watch a group of people, you will notice how people look when they are listening to someone. They concentrate and their faces are intent. An engaged mind shows vividly in the eyes and creates expressions of intensity on faces.

Never shoot people while they are talking. Wait for the moment when a person finishes making a comment; they usually pause right after and there may be an opportunity.

David Ben-Gurion, 1961

When we look at the intensity of Ben-Gurion's eyes and the beautifully dignified concentration on his face, we know that such a look could never be posed unless the person were a skilled actor. His eyes exude intelligence.

WHEN THE NEWLY elected John F. Kennedy and his wife visited Ottawa in 1961, Ted photographed Jackie Kennedy as she watched the RCMP Musical Ride. The first lady, a fearless horsewoman, was transfixed by the elaborate equestrian event performed by more than thirty police officers on horses as they executed an intricate cavalry drill choreographed to music and followed by a salute to the guests of honour. Her personal history allows her to observe the nuanced movements of the magnificent animals far beyond the pageantry that might entertain most onlookers.

"I understand portrait lighting in a studio and have trained myself to see it outside," Ted explains. "I look for the light, the eyes, the action, and then *click*. Outside of a studio, the luck of good lighting is always involved."

CHARLOTTE ELIZABETH WHITTON (see page 122) was the forty-sixth mayor of the City of Ottawa and the first female mayor of any major Canadian city—not to mention a proud feminist. Ted caught the fullness of Whitton's unquestionable determination with a photograph that many say sums up her indomitable character. Whitton was known as a feisty leader who ran a tight ship. She was Ottawa mayor in the early 1950s and '60s, at a time when few women held high-ranking positions. In her early days, she was the star of the women's hockey team at Queen's University and an accomplished speed skater.

It is interesting to compare the fieriness of this political pioneer with the serenity of the young novitiate on the opposite page. (See page 123.)

We walked along the halls chatting together, and as we cut through the chapel, a bell rang and it caused her to stop and say a brief prayer. I saw this perfect light on her face as she knelt down.

When I saw the extraordinary light and shadows around her, I photographed her, muttering to myself, "Jesus, look at that!"—before I realized it wasn't my best choice of words.

opposite **Jackie Kennedy Watching the RCMP Musical Ride in Ottawa, 1961**

With scores of other photographers seeking to catch a shot of one of the most photographed women in the world, Ted positioned himself so that he was capturing Jackie Kennedy with a soft light on her face. He waited until he observed her captivated eyes. It was a short wait.

NOT A POSED PORTRAIT

Charlotte Whitton, 1958

Whitton is remembered for saying "Whatever women do they must do twice as well as men to be thought half as good. Luckily, this is not difficult." Never afraid to speak her mind, Whitton was being interviewed on the radio when Ted, observing through a glass partition, snapped this photo. "She had no idea I was taking that picture," he says. "If a person is aware of the photographer when they are having their picture taken, something changes."

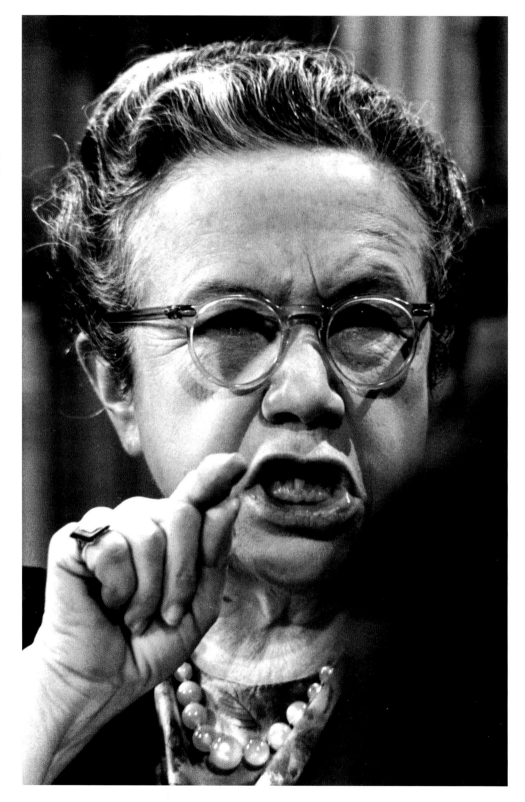

TED GRANT

Nun in Training, 1965

Ted had the opportunity to visit a convent in Hull in 1965 with NFB filmmakers who were producing a film there. Ted, assigned to take the accompanying photographs, was mesmerized by the beauty and tranquility of this young nun in training.

BOBBY ORR, ALSO known as the gentleman of Canadian hockey, was in the stands with his friends when Ted shot the following photo. The portrait-like shot of player #4 was published in *Sports Canada*.

Although I didn't pose him purposely for this photo, I did ask him to sit in the stands, where he became engaged in conversation with a couple of other players. The image points at opportunities for a quiet, natural, photo portrait when a person is engaged in conversation and listening. It is not a million-dollar picture, but Bobby Orr was pleased with it.

IN 1968, THE NFB sent Ted on an assignment to Japan for a story on the country's manufacturing of goods and trade with Canada. While visiting a tangerine farm, Ted spoke to one of the farmers through an interpreter. (See page 128.)

I couldn't speak her language, so I advised the interpreter to touch my shoulder and follow my body and keep talking to her. She is listening to him with her eyes. And I kept moving until I had the right light on her face. I waited till I saw the butterfly lighting under her nose. Butterfly lighting is used in studios for portrait photography; the term refers to the shape of the shadow under the nose.

Bobby Orr, 1969

This simple picture of Bobby Orr at age twenty-one during his third season with the Boston Bruins, taken in the old Boston arena, captures the familiar face of a much-loved athlete.

IRENE GRANT AND her granddaughter were playing in the backyard on a sunny day when Ted returned home from shooting a football game. By chance, he still had his camera conveniently set with a 280 mm lens from the game.

I looked over and Grandma and our grandchild were rubbing noses in the garden. I focused manually and shot. They didn't even know I was shooting pictures. If they did, it would have lost the naturalness.

Light is the life of a picture, and content is the soul. The two aspects come together in this image. There is so much light around both of them. Irene's white sweater was throwing reflected light into our granddaughter's face and the light hitting her is throwing light back to Irene. So there is a nice balance of light. Even the light hitting the tips of Irene's eyelashes is featured from the shadow side. I didn't see all of the details at the time, but I reacted to my gut feeling.

When you see something and feel something; be prepared to shoot. We lose the photography impact moment when we focus too heavily on pixels and technology. Energy would be better spent understanding light and observing how it is shining.

Grandma Irene Grant, 1994

This photo of Ted's beloved wife and granddaughter has been used in several ad campaigns and won a number of awards.

Tangerine Farmer in Japan, 1968

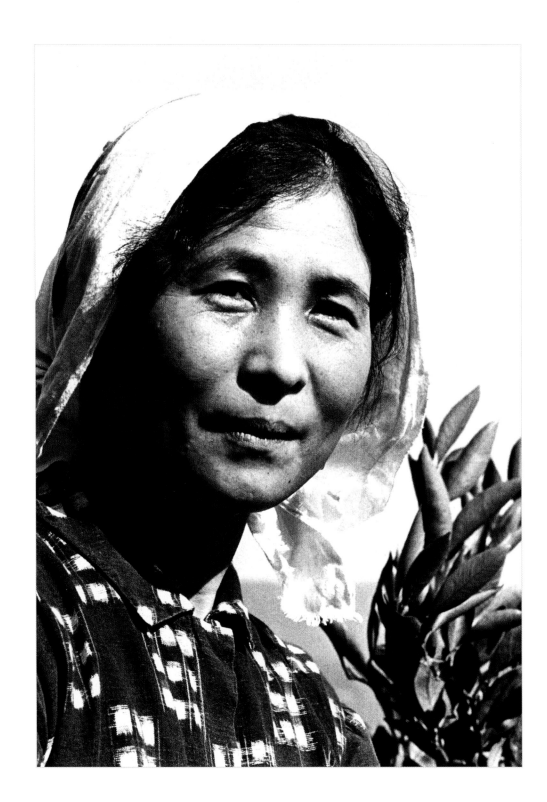

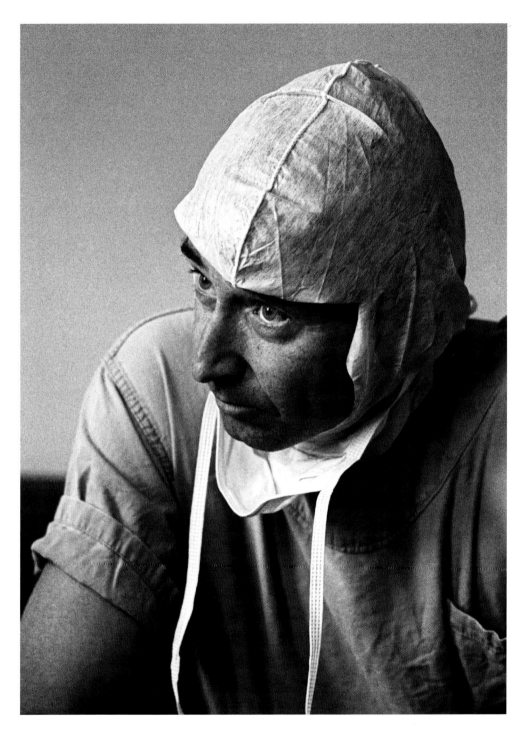

Dr. Jim Dutton, 1983

The portrait-like, strikingly intense image of Dr. Dutton in the operating room appears on the cover of Ted's book *Doctors' Work: The Legacy of Sir William Osler*, published in 2003. Ted captured the shot when the cardiologist was consulting with a colleague on a patient's heart valve replacement surgery. Ted, clad in scrubs and with cameras ready, worked a few feet away from the patient and surgery team.

America Never Fails, 1962

Before the dawn of the internet comments section, some people had to literally stand on a soapbox to speak their minds. Ted took this shot in London's famed Hyde Park on a Sunday evening in the early '60s. While some things haven't changed—American politics were as much a hot topic around the world then as they are today—the way people respond to controversial or opposing points of view have sadly degenerated in the era of online media and twenty-four-hour news. "What intrigued me was that no one was fighting," recalls Ted of the day he shot this photo. "People just respectfully listened for a while and then went on their way."

Ted Grant, Self-Portrait at Seventy-Six Years Old, 2003

Septuagenarian Ted Grant exhibits the same level of passion for life as for photography. "I was sitting directly behind the pilot and determined to get photo proof of flying upside down at four thousand feet. With arms outstretched in front of me, I held a digital camera aimed at myself and pressed it against the back of the pilot's seat. As he took the plane into rollovers, I just held down on the motor drive button. A rapid succession of clicks produced a frame-by-frame playback of the wild ride. The experience was very cool!"

6 THE MEDICAL YEARS

TED'S PINNACLE

Photography opens up your eyes. You see things you normally wouldn't see.

SUE RODRIGUEZ
Advocate of Assisted Suicide and Lesser Known
to Canadians as a Freelance Photographer, 1993

Unlike many people, who begin to fantasize about retiring at fifty, Ted was just beginning his most important work at that age. It was around this time that he went to Houston to shoot the promotional stills for *Urban Cowboy.* He had to push himself to do the assignment, however, because he started developing terrible migraines. At one point he thought the smoke on the movie set was aggravating him. A while later he had four molars removed, thinking they were the problem, before learning the trouble was from an exceedingly painful condition related to the trigeminal nerve at the back of the head. He suffered with it for six months before doctors figured out the cause.

Prior to a scheduled surgery to repair the condition, Ted collapsed. As always, Irene was there to pick him up and arrange for the best possible support. With a fancy fluke of fate, as Ted seemed to be sliding downhill physically, he was suddenly drawn to a new passion that invigorated him and informed his work for the next three decades.

opposite

Dr. Brien Benoit, 1979

Dr. Benoit, the surgeon who healed Ted and sparked a new-found passion for medical photography, captured in a moment of deep concentration.

133

He was in the operating room being prepped for surgery when, moments before the anesthetic took effect, he had an idea.

"Hey," he thought, "this would be a great place to shoot. I wonder what it would be like to . . ."

Over the four months of his post-operation recovery time, Ted became friends with his surgeon, Dr. Brien Benoit, who was chief of neurosurgery at Ottawa Civic Hospital. By the time he could look through a camera and focus again, he had already asked to spend a week with Dr. Benoit in his operating room—not on the table this time; he wanted to have a record of the doctor who fixed him.

Having excelled in so many different facets of photojournalism, Ted was about to add one more photographic category to his already diverse portfolio.

Watching medical staff go about their intense work satisfied Ted's desire to appreciate and observe life from this unaccustomed vantage point. A new and abundant round of passion stirred his idealistic sensibilities. There was magic in photographing the people who supported life. He propped himself up against a wall or on the floor with a 200 mm lens and waited for the moment to capture the treasures he saw in the hands and eyes of the operating room staff. Observing the professionals peering into human bodies sparked Ted's own love of life.

After Ted and Irene moved to Victoria in 1981, Ted met Dr. Jim Dutton and showed him the powerful and compassionate black-and-white photos he had taken with Dr. Benoit. Dr. Dutton appreciated Ted's masterful work that brought to mind an old volume he had of aphorisms by Sir William Osler, the eminent nineteenth-century Canadian physician who is credited with, among other things, bringing medical students out of the university lecture halls and to the bedsides of patients as part of their training. Dutton shared the book with Ted, who read through the quotations and immediately saw how he could marry Osler's profound hundred-year-old words to many of the images he had taken in the hospital in Ottawa. The combination proved to be a natural dovetail.

Ted learned to prize the low-lit, silent, antiseptic environment. He visited hospitals, followed nurses and doctors in their daily routines, and began photographing everything medical. He satisfied his curiosity about a world filled with an intensity of healers going about their business.

Masked and dressed in green scrubs and discernable only by the black camera he held, Ted slipped, with precision, through the limited space in between members of the operating room staff. Careful to never get in the way, Ted and his silent Leica were nearly invisible to the dedicated professionals who made up the hospital team.

Using only the operating room light, he captured the interplay of skillful hands and eyes intently concentrated on mending the bodies beneath them.

"All of my medical work was shot in existing light. No flash," Ted explains. "Imagine being in an operating room and trying to use flash. You wouldn't be in that room very long!"

Later at home, usually the same day, Ted would get another rush from developing his film and discovering and editing the images he planned to use as a part of his first medical book. Irene looked at the new photographs Ted had spread on the dining room table every day for her critique and comments. As a nurse, she had a vested interest. She believed Ted was creating an important body of work that had value. *This is Our Work: The Legacy of Sir William Osler* was the result, a substantial and luxurious book of medical photographs published in 1994. It was an impressive showcase of Ted's work, as well as a tribute to the voice of a legendary Canadian physician.

"There have been photographs in operating rooms for a long time, but Ted brought a different feel to the work," explains Dr. Dutton. "He understood what physicians were trying to do. I have never seen anyone convey the work the way Ted did. The images were so respectful."

The images convey a sense of place most Canadians associate with healing and support from the inner sanctums of our universal health-care system. Unlike many other nations on the planet, where unexpected doctors' appointments and end-of-life care can be fearful precipices of debt, Canadians are likely to have a more positive interpretation of the images.

Unfortunately the publisher went bankrupt shortly after the publication of Ted's book, leaving Ted and Irene with a huge disappointment, a major financial loss, and stacks of beautiful books. But much like in his early days when he spent unpaid time with mentors, Ted saw the value in this decade-long experience. His early medical work unexpectedly became one more expression of his commitment to giving back to his community.

Fortunately, their children were grown and Irene was working full-time as a nurse and supported Ted as strongly as ever. Neither Ted nor Irene was sure how the medical work might eventually pay off, but Ted continued to draw on his inner resilience and good nature and kept taking assignments to pay the bills.

After thirty years of marriage, Irene still had to remind Ted to put down the camera and eat the meal she had just prepared. He could easily get lost in his work, with "just one more picture to take, or to crop, or to develop." She embodied the wise and practical end of the partnership that always helped Ted maintain a semblance of balance between living and working.

I will never forget the first time I photographed a child being born for an NFB assignment early in my career. That was long before the explicit TV programs they have now. Since then, I have photographed any number of babies being born. Sometimes there is a lot of yelling going on and you have to keep focused on getting the right picture. Time becomes irrelevant. You are there and you just have to wait it out.

I always stand by the mother's head. There are no pictures at the other end. A wide-angle lens shot, taken from beside the mother's face, will include mother, father, baby, and doctors. You can turn and get a few expressions from her and also catch the moment the doctors show the mother the new baby. At the other end of the mother's body you completely miss that critical shot.

One of Ted's early birthing assignments had him waiting by the phone for expectant families to call him and say it was time to go to the hospital. He was called eight times—six times he got there mere moments after the baby was born; the other two calls turned out to be false labours. Finally, after some frustration, Ted was invited to come to the delivery room at 7:00 a.m. on a Wednesday; the doctor was inducing labour. That day, he ended up shooting six births.

It was like popcorn. I was all set and changed into scrubs and was introduced to a mother-to-be. We had a good chat. It was her first child and I made sure she was comfortable with my presence.

In birthing, respect is key. If you need to go from the left to the right side of the bed and you must walk around the mother's feet, you don't look at her. The mother can still see you and she has enough on her mind without feeling strange about someone taking pictures. You just don't go there.

One baby that day was completely blue. There was no pink skin. It scared the hell out of me. But then it started to cry and immediately started changing colour. Seconds later it became a pink, wrinkled-up kid.

I have cried at every birth. It is just one of those inevitable things.

In the '50s when Ted's children were born, men were not permitted in the delivery room. However, Ted feels blessed to have since had the chance to witness and photograph more than 150 births, including those of most of his ten grandchildren. He has supplied memorable photographs to more than a few well-intentioned but faint-hearted young fathers who passed out at the crucial moment and ended up being yarded across the delivery room floor and heaped into a corner by a seasoned nurse.

After reviewing a broad selection of fabulous birth pictures from the archives and narrowing them down to two images, I asked Ted to choose which one he preferred for inclusion in this book. It was like asking him to choose between his own children. He kept looking from one to the other. He tried and went back and forth, and then stumbled and finally apologized, saying he just couldn't choose. After watching Ted's angst at having to make such a choice, and appreciating his dilemma, I realized that both images had to be included.

They are completely different stories. When I saw the mother reach out to touch her new baby's hand, I thought, "Oh, my god. This is the first time she is holding that tiny hand." And in the other, I watched the father, leaning forward with his strong arm holding up the mother's head so that she could see their new baby for the first time.

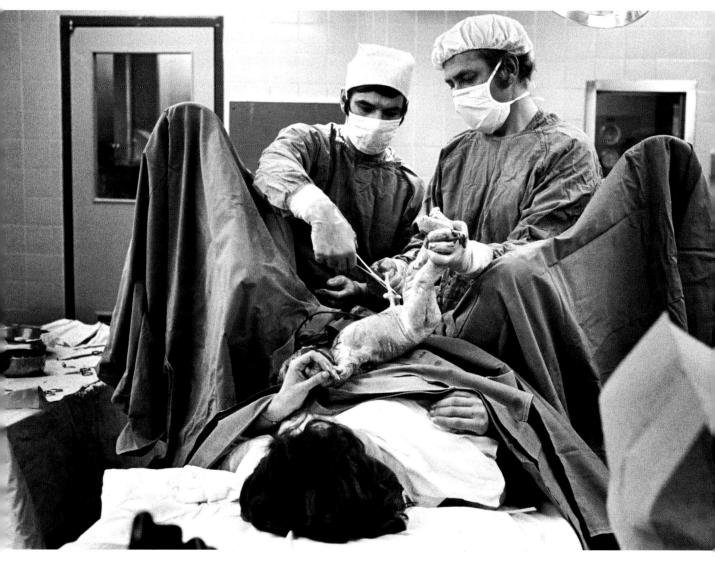

First Time for Mother Holding Hands with Her Child, 1976

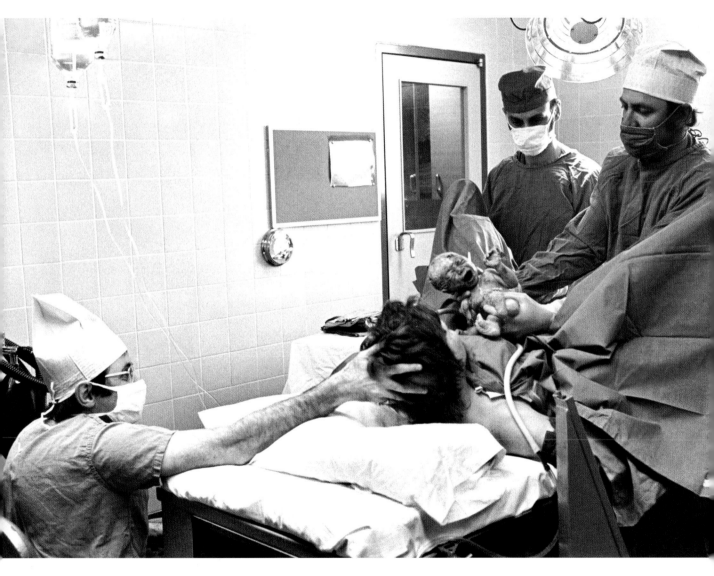

Father Holding Mother's Head to See Their Child, 1976

NINE YEARS AFTER the disastrous experience with his first medical book, the project was revived. With an improved title—*Doctors' Work: The Legacy of Sir William Osler*—and added material, the impressive collection received critical acclaim from both the medical and the photographic community.

> *A doctor who bought the book told me that after a rough day at the hospital, he sometimes pours himself a drink and relaxes while looking through it. He said it reminds him of why he became a doctor in the first place. Nothing could please me more than knowing my work has offered this kind of comfort to a hard-working doctor.*

Shortly after the book was published, Ted was giving one of his annual Cape Cod Leica International lectures when he was approached by a teaching doctor from Yale University who was also an avid amateur photographer. He appreciated Ted's published medical work and invited him to present three lectures to his medical students. All the sessions were packed with an energetic young audience, and Ted vowed to do more work with medical students in the future.

Of the eight books that Ted has published so far, three have been dedicated to the medical profession.

> *Shooting the medical scene is as different from shooting sports as midnight is from high noon. The operating room presents completely opposite challenges from the international sports scene, where the action and competition among throngs of photographers is intense. Other than a few softly spoken words, the operating room is usually silent. Surgeons concentrate acutely during an operation; it is awe inspiring to watch their eyes.*
>
> *I observe and capture my subjects just as my heart relates to the moment. My way has always been to capture life—regardless of subject or location—in as straightforward and truthful a manner as possible.*

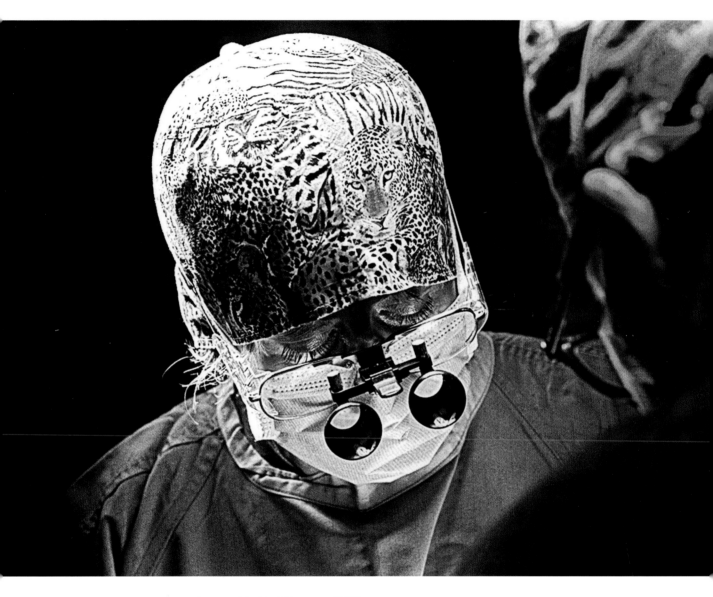

Leopard-hatted Surgeon, 1985

A whimsical departure from the drab old green and blue operating room attire, this surgeon's exotic animal-print surgical cap is an interesting visual contrast to his intense concentration while performing heart surgery.

Dr. Jim Dutton, 1995

Ted photographs Dr. Dutton's compassionate expression in a private moment between heart surgeon and patient. The image offers yet another opportunity for us to be in the room, witnessing a very personal conversation. The shot almost makes us feel as if we are behind the patient's eyes.

IN 1993, TED had an assignment from a magazine called *This Country Canada* to photograph Sue Rodriguez, the passionate advocate for doctor-assisted suicide. At that point, Rodriguez's ALS (also known as Lou Gehrig's disease) had left her completely incapacitated and dependent on others for the most basic tasks. A freelance photographer herself, Rodriguez understood and approved of Ted's approach to the assignment.

> She was a very calm and caring woman with a vibrant mental alertness. While I was shooting, she received a phone call, and I guess the information she was getting was quite stressful. She started to cry. I left the room as her caregiver had a private conversation with her. I nipped into the living room and took a seat and made sure to give her the space she needed. She had the most wonderful and respectful support people.
>
> I don't know that I was as successful as I would like to have been that day, but it seemed to be an especially difficult time for her, and that became the priority. This very strong woman confirmed my belief in the need for more compassionate discussion about assisted suicide. She was remarkable.

A particularly playful image was captured in an examination at the Montreal Children's Hospital, where Ted spent an afternoon shadowing a young family doctor.

> I don't speak French very well, so I didn't know what they were saying. But then I didn't really need to know. The doctor said something in French and then both he and the child stuck out their tongues. I always have the camera in my hands. If I had been standing with my hands at my side, I would have missed the shot.

As a photojournalist, Ted's job is to see what any one of us might see if we were not so caught up in our day-to-day thoughts. The productive work of his medical years brought

continued on page 146

opposite *Sue Rodriguez with Support, 1993*

The face of the right-to-die movement, Sue Rodriguez became one of the most controversial figures of the early '90s. Her amazing bravery in the midst of all her physical suffering brought hope to thousands suffering from debilitating illnesses.

above *Montreal Children's Hospital—Sticking Out Tongues, 1985*

insight to outsiders. He has given us a chance to appreciate the determined human efforts to cope with disease.

When looking at the unmistakable authenticity of Ted's medical work, you cannot help but wonder if his success is related to the fact that viewers crave truth amid the sensationalistic news stories and Hollywood dramas.

THE NUCLEAR ACCIDENT at Chernobyl in 1986 prompted one of Ted's most heartbreaking assignments. He was invited to Moscow after Dr. Dutton introduced a selection of Ted's medical shots to doctors at the Russian Academy of Medical Science. The doctors admired Ted's work and, in 1992, asked him to document the children suffering from the impact of the Chernobyl disaster and undergoing treatment in Moscow.

The work that resulted from Ted's trip to Moscow left him sad and angry with the international leaders who make decisions about nuclear power and other large societal issues that leave children suffering. Unlike many of the children he had encountered at other hospitals, the children of Chernobyl did not appear to have any joy in their eyes or hope for the future.

Dr. Dutton recently suggested that Ted speak to a post-traumatic stress counselor to deal with the residual sadness he feels when he looks at his photographs of the children of Chernobyl. More than twenty years after meeting the children and completing the work, Ted remembers the assignment vividly.

I don't see it affecting me on an everyday basis, but whenever I added the Chernobyl pictures to a presentation, Irene said, "Don't put that picture in; you know how it affects you."

You see these little guys with cancers and tumours. It was terrible. Something like this, happening to children, affects everyone on the planet. Some photographers are able to separate themselves from the images they are paid to get. That might be a nice shield to protect yourself, but I have never been able to do that.

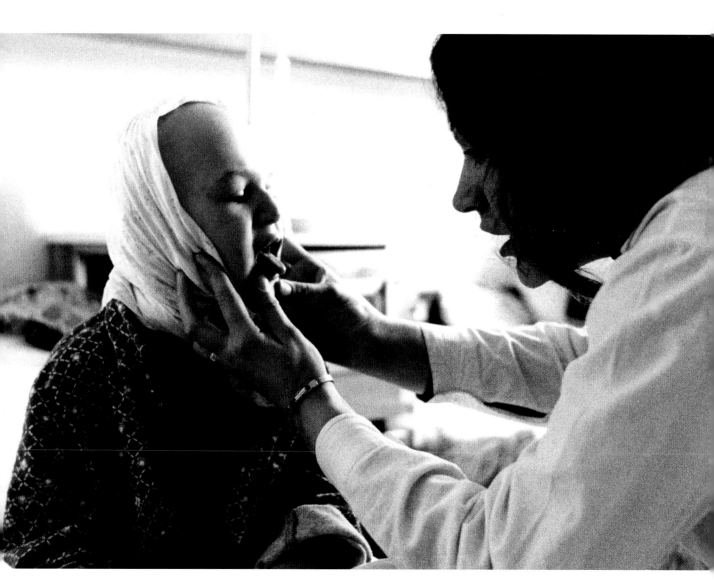

Chernobyl Child Sticking Out Tongue, 1992

The child wearing a scarf to cover her baldness is also sticking out her tongue, but she is not surrounded by the same supports as the boy in Montreal. She is still cared for by dedicated medical professionals, but the trauma of Chernobyl will inevitably stay with her.

Chernobyl Boy and Car, 1992

What could the glaring eyes of the six-year-old boy with the bald head be saying to us? "That child didn't smile," Ted recalls. "There was something about the look in his eyes. He looked right through you. In my mind, the caption to his image says: 'Look at what you bastards did to me.'"

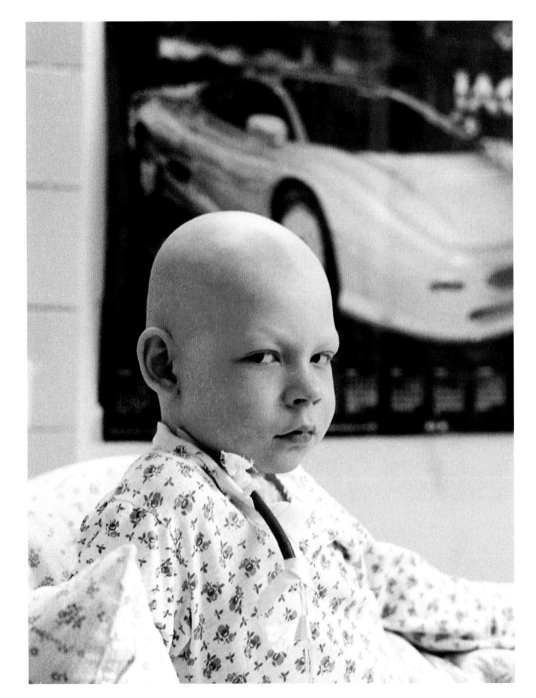

Chernobyl Boy before Testing, 1992

One of the Chernobyl boys goes through a brain test to locate cancerous growths. He looks sad, tired, and at the end of his tether.

Chernobyl Boy Being Tested, 1992

This boy was placed in a very small room and asked to sit in a chair. The door was shut and the light turned off. Over the child's head a strobe light flickered as the machine took its reading and searched through his brain.

"The technician was on the child's left and I was on the right kneeling on the floor," Ted recalls. "The technician turned lights off and everything went blacker than black. I wondered how I was going to work with the available light when there was none. And then as the strobe went off, I realized I could adjust the speed dial to 'bulb' and squeeze down to allow the lens to stay open. It worked. I was able to capture him midway through the test."

IF HIS TIME in the former Soviet Union causes Ted post-traumatic sadness, much of his other work brings him joy. He is easily and often moved to healthy tears of gratitude. The Japanese word *kanrui,* for which no single English equivalent exists, describes those precious tears we associate with joyful birth or other moving occasions. Ted is a man who is often moved to *kanrui* by many aspects of his work as a photojournalist.

In 1996, Ted worked on an assignment with Sandy Carter, a student from the Western Academy of Photography in Victoria.

"Within a month of my graduation, Ted called me to say he needed an assistant. I thought that was my lucky day," Carter says. "I would have worked for free just for the opportunity to learn from him. When I arrived on the first day, we had to negotiate how much he was going to pay me. I didn't know what to ask. He suggested $12 an hour, and I countered with $10, following it up by saying I was sure he would want to give me a raise once he saw what I could do."

Ted accepted and what began as a mentorship evolved over their ten-year association into a highly successful business partnership.

"At first I was pretty awestruck to be working with *the* Ted Grant," she says. "Throughout my time with Ted, I had a great opportunity to learn so much, and I learned most of it in the darkroom. His darkroom skills were the best. They became the transferable skills that I now use in my digital work.

"He taught me to see the light. He taught me to shoot from the shadow side. He taught me to bend my knees—a lower viewpoint adds interest to many photographs. And he taught me about having fun with the work. The decade I spent working with Ted was by far the best thing that ever happened to my photographic career."

Carter's business savvy brought Ted more recognition and financial gain than he would have achieved on his own. The sale of one photograph to a large New York corporation allowed Ted and Irene to buy a Mercedes. Had he negotiated the deal on his own, Ted would have likely charged a quarter of the amount. Ted made more in that one year with Carter's help than he had in the several years before. She was glad to facilitate the windfall for her good friends.

Sandy Carter with Ted, 1998

To Ted's good fortune, Carter evolved from an efficient assistant into a highly talented photographer and ultimately into a savvy business negotiator who cut some of Ted's best deals.

"Irene was one of my best friends," Carter explained, on her first visit to Ted's home after Irene's death. "She was the funniest person. She always called it like she saw it. What more do you want in a friend than 100 percent honesty?"

Ted and Carter bought their first digital cameras together in early 2000.

"I was working mornings with Ted, and if we had a big project we would work all day. He was in his sixties then and was beginning to slow down."

Ted and Carter were working on a contract for a pharmaceutical company in New York when they met Dr. Jennifer Mieres, a cardiologist. Ted showed her a copy of *Doctors' Work*.

"Why don't you do a book about women in medicine?" she suggested.

Her simple question led to a remarkable work by Ted and Carter. *Women in Medicine*, published in 2004, is a moving photographic tribute to women health-care providers, who make up 80 percent of medical professionals throughout the world. Ted invited Carter to participate as an equal partner on the project as he thought the book would have greater value if they collaborated as partners.

I felt we needed to be a team for that project. It would be in the best interest of the patients we were photographing, and to be honest, in my own best interests also. I didn't want either me or the patients to feel awkward in any way by personal issues that might arise.

Carter has fond memories of the project. "It was my first experience shooting in an operating room," she recalls. "We went to hospitals in Montreal, Toronto, New York, and Boston, and through Ted's contacts we were able to get into these places with very little red tape. We had great access, and never got caught up in the kind of bureaucracy you might imagine around those situations."

In the book, they attempted to represent the women in medicine most of us encounter in health-related situations from birth until death. Physicians, nurses, researchers, midwives, technologists, therapists, physicians' assistants, and volunteers were feted. Candid images taken during their workday came together to form a thoughtful celebration of women's historical roles as caretakers. The contributions of women in medicine throughout history have never been more beautifully honoured.

Although Carter began as a support person to Ted, he explains that in the final years of their business partnership, he could not tell their medical work apart.

"Ted always advised me to shoot anything that tweaked my interest," Carter says. "Over the decade of working together, I came to appreciate the full range of his fine ability to do just that. His work covers a broad range of disciplines and all of it is great. He continues to produce masterful stuff even now."

Carter now lives in the States and only works with Ted on occasion. She went on to become a successful photographer working on shoots all over the world, "but the very best time I've had was working with Ted on *Women in Medicine*," she says.

Carter viewed Ted's darkroom skills much the same way that Ted saw Stan Hunt's masterful darkroom skills back at the start of his career at Newton Photos.

AFTER A SIX-DECADE-LONG photographic journey that has taken him all over the world to cover an unparalleled diversity of subjects, Ted still finds energy to work with local medical students. It is no wonder that he is the only photographer to earn both the prestigious gold and silver medals for photographic excellence presented by the National Film Board of Canada.

As medicine transcends borders, the young medical students Ted photographs at the University of Victoria may someday become doctors who serve all over the globe, wherever they are needed.

UVic Medical Students, 2012

The skeleton in the foreground seems to be part of the class.

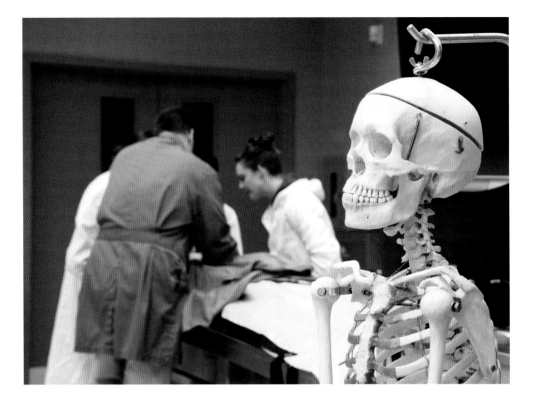

Ted Organizing UVic Medical Students for Grad Class Photo, 2012

Like many of his early mentors, who worked late into their lives, Ted is still fed by his passion in his eighty-fourth year.

My medical photography is not finished yet. There is still one project I would like to do and it might take me three or four years. Even now, working gives me the same spark of energy that I felt when I was going to the Olympics decades ago. There is something in the air—an upbeat energy that just turns your body on. I still believe my medical student photography book will happen, and possibly even one more book after that. Who knows! Without question, I am most proud of my medical work as it forms a record of the men and women devoted to caring for humankind.

When asked if there was a particular message Ted hoped to convey with all of his medical photography, he summed it up this way:

These are the people who look after us when we really need it. Look at their compassion and care and understanding. Look at how they do the hands-on thing when they are our comforters.

Ted's work continues to demonstrate his ability to connect with what is important in the lives of Canadians.

Little did Ted know that when he was working with the medical students and photographing the new hospital in Victoria that Irene would be among the first new patients in the facility. She lived her final days surrounded by the finest talent, technology, and medical support available anywhere in the world.

Dr. Ted, as He Is Affectionately Known, Receiving Honorary Degree, 2008

With Irene proudly sitting in the first row of the University of Victoria auditorium, Ted, in cap and gown, receives an honorary doctorate for his lifework.

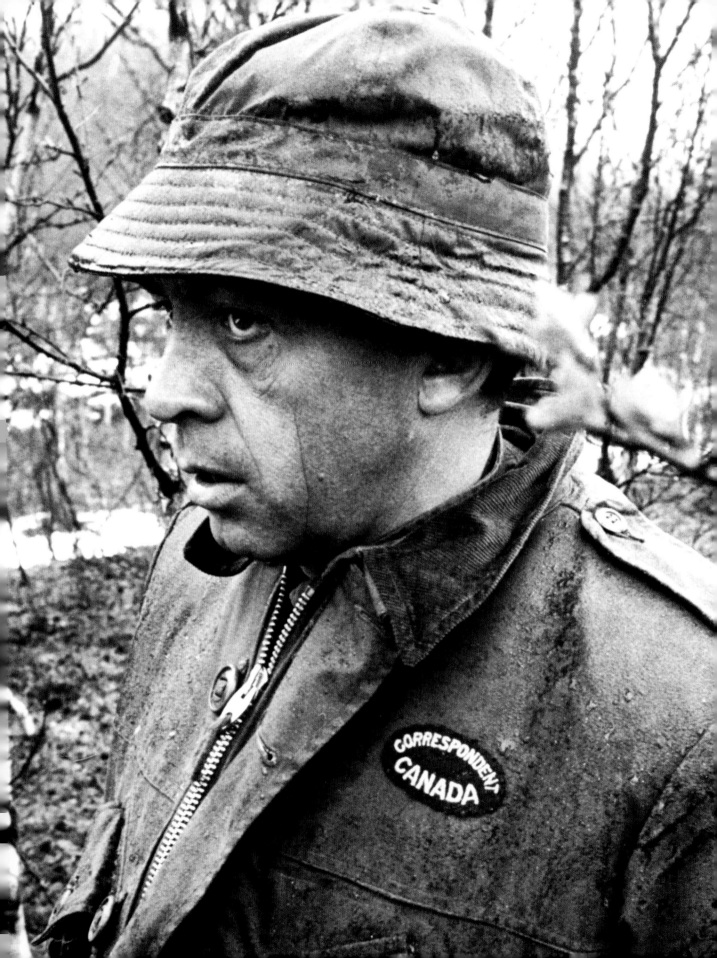

7 A WAR CORRESPONDENT'S REFLECTIONS

SHORT WARS, LONG SHADOWS

It would never suggest itself to any reasonable man to wash out ink spots with ink and oil stains with oil; it is only blood which has always to be washed out with new blood.

BERTHA VON SUTTNER
Novelist and Nobel Peace Prize Winner, 1889

War photography may not be symbolic of Ted's work, but his brief stint as a war correspondent in 1967 and '68, and his coverage of the Military War Games in Norway in '68, played a powerful role in his thinking and personal growth and ultimately in his decision to promote and observe the precious qualities of life. His diminished hearing as a result of being too close to artillery and tank fire serves as a reminder of that time.

The Six-Day War in the Middle East (also known as the Arab-Israeli War), is called the shortest war, but it still resulted in the deaths of more than 15,000 people. Ted rarely misses an opportunity to express the revulsion he feels at what he observed in the Middle East and Vietnam. He refuses to romanticize any of it. Yet, he does not judge photographers who make their living recording war atrocities. He acknowledges the decision to do so is a tough one.

opposite

Ted as a War Correspondent, 1968

At the press club in Ottawa, I had heard that a military information officer and corporal photographer were going over to do a story about the Canadian soldiers being airlifted out of the desert and heading to Pisa, Italy. There was a spare seat on board the military aircraft.

I called the Toronto Star *and said I had an opportunity to go to Pisa to see the Canadian troops coming out of the desert. They were interested in the story. That was in the newspaper era when the editorial staff had more influence than the advertising folks.*

I went to Trenton and got on the plane with some of the crews heading to Shannon, Ireland. Between Shannon and Pisa I was with a small crew and had the luxury of roaming freely because I was there under DND auspices—my only instruction was not to be too obvious.

I started shooting pictures of the troops while they were waiting for their next flights. I stopped and chatted with them and learned about the things that were going on in the desert. Then I got a message from Toronto telling me to go to Tel Aviv to meet up with Arnold Bruner, a Toronto Star *writer. That was on the Friday before the Six-Day War started.*

Arnold had a rental car, and we drove to different kibbutzim *and roamed around and observed the general preparedness for war. I saw a young mother walking with her kids. She was wearing a pink straw hat and a good dress and had an Uzi machine gun slung over her shoulder. People were blackout painting headlights on their cars. Shop owners were taping up windows.*

On Monday morning I was up early and headed for breakfast, and the service staff were crowded around a table with a radio. The signal that the war had started was the playing of the martial music over the airwaves.

Down the hall a CBC crew of three was still there; unlike most of the media people who had left the day before. People in the hotel were told to go into the basement because an air raid on Tel Aviv was expected.

By 9:00 a.m. we went to the main press centre for a briefing. The organizers had arranged for two large tour buses to take media people to the Sinai Desert. We headed out and started to see the destruction of

scattered military tanks and mutilated bodies. We passed an Israeli tank and were about fifty yards in front of it when it went over a landmine. The tank exploded into pieces.

Everyone on the bus was yelling and screaming to stop. The media people were a bit shook up, but they also wanted to get out and cover the event. There were no survivors in the tank. The metal was bent and torn and smoke was pouring from the wreckage.

The reporters started walking into the field until one of the senior officers started yelling at them to get back on the road and keep away from the mines. The reporters traced their own footprints back to the bus where they were severely tongue lashed. Nobody went off road again. We took photographs of aircraft that had been shot up near el-Arish.

One kibbutz *we went to had been getting shelled in the morning, and the community members were quite shaken. Then up pulled two busloads of journalists and you could see they didn't really want us around. We got herded up on a knoll and were getting the spiel about what was going on and what would be going on in the coming days, and all of a sudden artillery pieces began to fly. They boarded us all back on the bus and we left a community of people who were really annoyed that the busloads of media people standing on the knoll may have triggered another attack. The Egyptians may have thought we were a military presence.*

None of the media people I was with were experienced with this type of situation. One of the very foolish things we did as a group was not to bring water or food with us for the day, and quite a few of us got sick from dehydration. When we got back to the press centre in Tel Aviv, I must have drunk a gallon of tea and water. It amazed me how a little thing like dehydration could actually kill you.

I knew the CBC guys were shipping film out, so I sent mine with theirs and addressed it to the Toronto Star. *We were compatriots and had pretty good relationships, but still it was nice of them to do that.*

The war started on Monday, and on the Wednedsay, Ben Oyserman, an Israeli photographer reporting for the CBC, invited me to join him with an Israeli patrol. I got in his car at the press centre, and we were about to drive out, and at the last minute I got called to go with Bruner, who was headed up north because there had been a lot of action with the Syrians. He already arranged for a young lieutenant assigned as our guide, so I changed cars and we headed north.

Bruner was driving along cautiously as there were flames around us from the freestyle-burning fields on a hot day. We stopped and got out until the shelling stopped. Bruner was worrying about the car being hit, as it was rented on his American Express card.

We moved on down the road and came to Kibbutz Dan to get some good shots and then headed back to Tel Aviv. The first thing we heard when we returned to the media centre was that Ben Oyserman was dead, along with a group of Israeli soldiers.

They had been trying to move a roadblock and it blew up. I saw Ben's Nikon that had been hanging on his shoulder—there were shrapnel pieces right through; the camera was shredded.

It was one of those things. Bruner calling me to go up north that day saved my life.

Seeing the dead young soldiers in the desert was a real awakening. I had never seen bodies in a war scene before. Most of the pictures of dead military people that I had taken now had a larger context.

We went to prisoner-of-war camps and kibbutzim *to see how the people were coping. On the Saturday (their holy day) we went to Jerusalem. There were more bodies on the side of the road and shot-up tanks, but at that point there was no fighting going on.*

We went by the famous stables in Bethlehem, and there was a tour guide talking to soldiers who had taken their helmets off. The polite gesture seemed so ridiculous amid all the killing and destruction. We went to the Wailing Wall in the Old City of Jerusalem, which I found very moving.

I was born a Christian and know very little about the Jewish faith, but you could feel this was a very special, holy place. Soldiers were facing the wall and placing their slips of paper containing written prayers into the crevices. When you went down the stairs by this huge wall it was quiet, triggering my emotion and respect. I didn't feel it was the place to be taking photographs. When we were finished in Jerusalem, I packed up my gear and was ready and even anxious to leave. My mum and dad met me at the airport in Toronto, and I stayed at their home that first night back in Canada.

After my unsettling experience as a war correspondent in 1967, you'd think I would know better than to go again. But memories of the Second World War were still fresh in our minds, and the feelings from having been in the reserves somehow gave me the sense that I should go again when the opportunity presented itself the following year.

I had read a story about three Canadians who were volunteers with the American forces in the northern part of South Vietnam. A Reuters photographer had taken a picture of them brandishing their own little Canadian flag. That triggered someone from Weekend Magazine *to suggest I go over and try to track down the three Canadians during the Battle of Khe Sanh.*

When I arrived, I found the young Canadians and discovered they were there because they had heard a father or uncle or brother tell exciting stories about the Second World War.

It all seemed preposterous.

I quickly learned that I could get killed as easy as the guys with the guns, and it dawned on me that I had a wife and children at home, and that was exactly where I wanted to be. I decided to leave, and Weekend Magazine *was fine with my decision.*

However, I have always worn that decision as kind of an anchor. In a sense I ran away. It was the first time in my life I ever did that. I felt guilty because all those guys did not have the choice I had. I have only disclosed those feelings of sadness in the last few years.

It seems we go to countries where we do not speak the language or understand many of the nuances of the culture and we take a side based on our limited understanding of the "other's" long and complex history. It is as if through sheer willful blindness we choose to be empathetic to one particular side. It didn't make much sense to me then and it still doesn't now.

All these years later, I can't understand the idiocy of my own species. I wonder when the hell we are going to learn to accept and respect each other. I know the industrial war machine needs to keep going or else you have thousands of people out of work. But I would rather see people out of work than see them building more destructive war equipment. There is so much beauty in the world that we should be observing rather than fighting useless wars.

Ted kept his press cards from his time as a war correspondent, though he does not look back on that time fondly. His experiences in the Middle East and Vietnam opened up his eyes to the brutality of war.

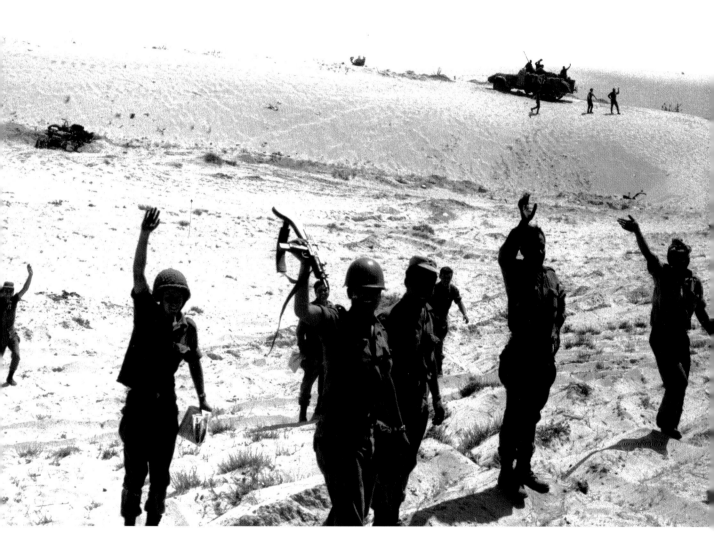

Victorious Israeli Soldiers, 1967

Israeli soldiers wave jubilantly in the desert. War was over for these smiling young men on Saturday, June 10, 1967.

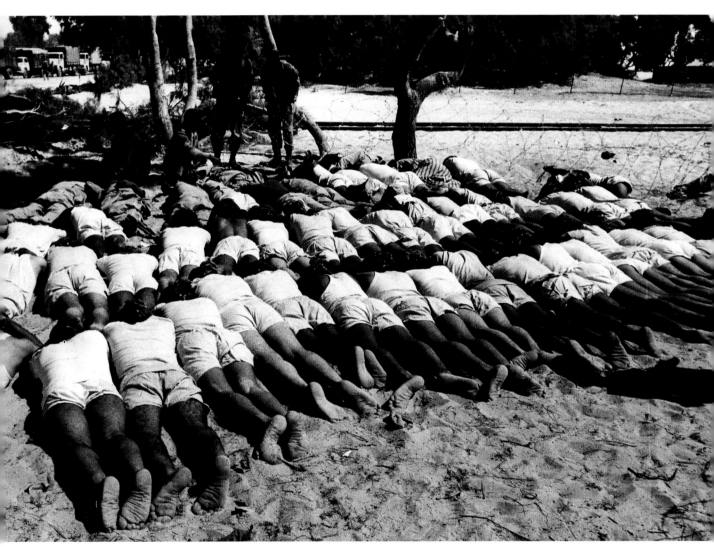

Defeated Egyptian Soldiers, 1967

These soldiers were captured in the desert and ordered to lie face down on the ground in a
small compound in el-Arish while awaiting the trucks that would take them to prison camps.

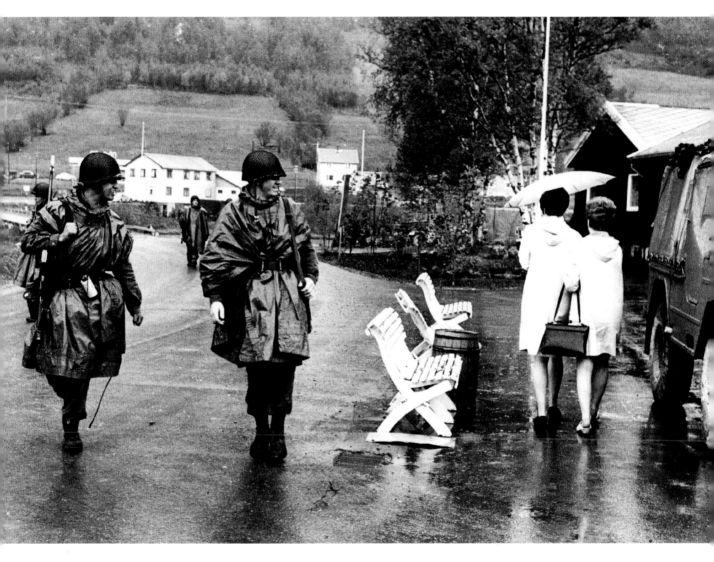

Young Canadian Soldiers at the War Games in Norway, 1968

In Norway during the Military War Games in 1968, Ted was walking the same way as these two Canadian soldiers, and he turned to take a second look. "These men were just smiling at the women," Ted recalls. "They weren't leering or lusting—just young men smiling at young women."

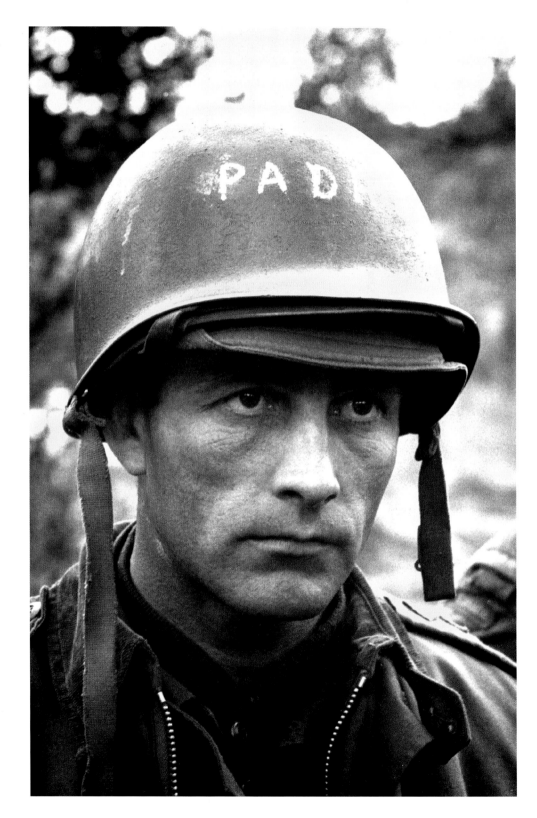

A Padre at the War Games in Norway, 1968

Motorcycle, Saigon, 1968

During his short-lived stint in Saigon during the Vietnam War, Ted made sure to capture scenes of everyday life amid the scars of combat. This shot of a man sleeping on a motorcycle makes one wonder at people's capacity to find ease and normalcy in any circumstances, even when sprawled across a motorcycle in the middle of a war zone. "The chap is lying on his motorbike as though he were in bed," Ted marvels. "Even his slippers are carefully placed beside the bike as they might appear beside a bed."

8 THE REAL CELEBRITIES
IN THE ARCHIVES

As a young photojournalist in 1955, Ted was one of more than nine million visitors from sixty-eight countries to see *The Family of Man*, a travelling photo exhibition. Curated by Edward Jean Steichen, director of photography at New York's Museum of Modern Art (MOMA), the exhibition marked a turning point in photography appreciation. The show was composed of 503 photos and represented the work of 273 photographers. Steichen's goal was to create a snapshot of the human experience and validate the role of photography in its documentation. The black-and-white images were full of magic for Ted. He never forgot the inspiring impact of *The Family of Man* display, and he determined to emulate the show's essence in his own future work.

According to Professor Joan M. Schwartz of Queen's University—specialist in photography acquisition and research at the National Archives of Canada for more than two decades—Ted has succeeded in his goal.

"Ted's ability to evoke lived experience through an individual image makes his work exciting. But also the range and depth of his work stands out. Above all, it is his humanity,

opposite

East Coast Fishermen Playing Cards, 1968

Lobster fishermen shoot the breeze and play cards in Nova Scotia while waiting for the wind to calm down. They know that nature will eventually accommodate them. Look at the wizened hand in the centre of the table.

passion, and engagement that come through in his more recent projects, from the aftermath of Chernobyl to women in medicine.

"Ted has always been kind and caring, and modest and motivated. His use of the camera, quite apart from his technical mastery, has been to open eyes and hearts, and to increase awareness, support causes, and celebrate excellence."

It is hard to imagine what more we could ask of a dedicated Canadian artist. The Ted Grant Special Collections at the national archives is filled with photo negatives of average, everyday, hard-working Canadians. This chapter contains a very small selection of images that I chose for no other reason than that they spoke to me in my research. They may not be the best shots of the 300,000, but they are worth pondering and reflecting on.

If you spend a few days looking at even a small portion of the Ted Grant Special Collections, you would surely make your own great discoveries. Under the guidance of archive staff like Jean Matheson, Lynn LaFontaine, and Dora Winter, you would be instructed to don white gloves, use only pencil on the premises (ink can damage the stored work), and keep your camera strap attached to your wrist at all times when you are taking reference photos. Keep in mind that handling plastic sleeves of negatives while wearing white cotton gloves—two sizes too large—can be time consuming.

You would be able to look at Ted's treasury of work in a room designated for viewing the Special Collections. You would come across a good selection of images related to the pomp and pageantry of a nation's usual assortment of historical occasions. And beyond that, in the carefully numbered boxes of negatives, you would observe respectfully photographed documentation—story upon story of the lives of Canadian people dating back sixty years. To study the full body of Ted's work is to study Canadian history, geography, and culture. You would come away richer for your discoveries.

If people could only see the wealth of carefully selected and stored images, I doubt there is a single person who would not choose to give up some of the defence budget to accommodate the continued care of our archived past. There is so much to learn from it.

To mention a few items from the '60s alone, you would find a series Ted did on male nurses, early anti-smoking rallies on Parliament Hill, rigorous training profiles of the first meter maids (early policewomen), the regimens of ice fishermen in the north, training boot

camp for RCMP newbies, a collection of photographs of students at a hairdressing school, and blue-collar guys in CNR workshops. The list goes on. There is even documentation of young kids skateboarding in Ontario.

Ted has captured working people of every stripe in every region of the country—and none of it is posed. The bulk of Ted's lifework has recorded more of the paths of hard-working people than of society's elite, reflecting the type of subject that is close his heart.

When I asked Ted which childhood story was most memorable to him, he did not hesitate before blurting out "Robin Hood."

> *I always thought Robin Hood's approach was neat, and although I never thought about it before, as I look back on it now, his way of being was in line with the strong blue-collar upbringing and values I learned from my mother and father. The storybook hero didn't focus his efforts on the wealthy as so many people do.*

Ted might argue the link is too remote to his practical way of thinking, but if there is validity in the parallels drawn by psychologists between a life course and a most significant and remembered fairy tale, Ted's case could be a fine example.

It seems somewhat fitting that the only time Ted completely flubbed an assignment was when he was photographing Queen Elizabeth in 1967. While the queen and her husband, Prince Philip, were in Montreal visiting Expo, three photographers were selected for a private opportunity to photograph the queen before the couple boarded HMY *Britannia*.

> *We were escorted to the location and told not to take any pictures until we were given a signal. Normally I would have three Leica cameras hanging on my neck, but for some reason I had only brought one into the room. I have no idea why.*
>
> *Her Majesty entered the room and took her position, and we were given a nod by the equerry. I took my first shot, and when I went to advance the film for another, I realized there was no film in my camera!*

I quickly moved to the equerry and explained. He looked at me and, with some disdain, said, "Pity," and escorted Her Majesty out of the room. Fortunately my two buddies saved my butt by slipping me a couple of their negatives. It may seem funny now, but trust me, it wasn't a laughing matter at the time.

Ted loves to tell the yarn to students and usually gets more than a few laughs when he delivers his final, excessively accented "Pity" line. He uses the example as a reminder that luck constantly plays a role in our professional lives. He feels that luck has been on his side throughout most of his career.

AFTER A BRIEF look at the seventeen images in this chapter, Dr. Phyllis Marie Jensen, a Jungian analyst based in Vancouver, spent thirty minutes giving me her first impressions of Ted's work. The former university professor, who holds a Ph.D. in health systems and behaviour and has twenty years of clinical experience in psychotherapy behind her, offered a rich and exacting interpretation of Ted's work.

"We have become so attuned to 'celebrity' in our media," Dr. Jensen began after a few moments of reflection. "If you look at newspapers, so much of our so-called news is really about celebrity. There is not much recognition or understanding or space given to the working lives of average people."

She went on to elaborate that what some may consider "average" people are actually quite remarkable.

"None of these pictures you just showed me is average. Ted is capturing the uniqueness of these very skilled people. It is not like I could just pop in and do any of their jobs. We are talking about knowledge and skill here, and you can see that in these pictures. They have so much meaning to us because these people are not created celebrities. They are down-home, you-me-and-my-neighbours kind of people."

According to Dr. Jensen, Ted's photos show us "how people adapt to Canada's physical reality. If you look at the farmer in the Okanagan orchard, you see the woman's soul shine

through. Carl Jung talks about how we incorporate the soul of the land by working on it. These people are relating to the land in ways similar to the ways their ancestors did."

As our nation becomes increasingly urban, people who work with primary resources are becoming a minority.

"Generally, Canadians don't have enough of a sense of our country," Dr. Jensen asserts, "and these images help [connect people with the land]. We are a multifaceted, cultural mix. What Ted is doing is going beyond the multiculturalism and taking pictures of people in relation to the land."

"Jungians say there are no accidents," she concluded. "The queen's presence may have presented an opportunity for most photojournalists, but photographing royalty is not where Ted's soul is. Future generations of Canadians will realize how valuable this work is. There are many pictures of the queen. Who cares if Ted did not take one more?"

I was surprised by the spontaneity, depth, and immediacy of Dr. Jensen's comments. Yet I had to wonder how different our society would be if Canadians appreciated the people in Ted's images as the "real celebrities" of our time. Before our meeting ended, Dr. Jensen added one final comment:

"Biographers often try to find scandal because they think it sells. They are doing what is typical. Maybe it does sell. The fact that you are not looking for a Freudian interpretation or trying to find the symptoms of his neurosis interests me. Your approach is uncommon and respectful."

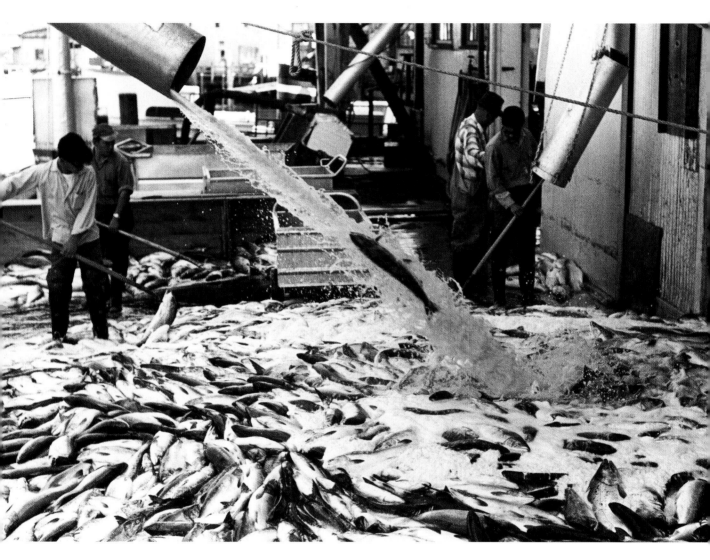

Fishing Plant, 1968

On an NFB documentary shoot, Ted photographed these fishermen unloading their catch of fresh salmon at a plant in Steveston, BC. "I got lucky with that shot," Ted recalls. "Not so lucky another time when I was invited on a salmon fishing boat off the BC coast with fisheries inspectors who were checking stocks of fish. It was not one of the smoothest rides. As they were hauling nets, I was standing on the roof of the wheelhouse. The boat was rolling and rocking, and I started to feel sick. They were bringing in the first big net of fish and I couldn't miss the shots, but I had to throw up. I leaned to the opposite side to be sick and then ran back to shoot more pictures. This went on several times. Sometimes you just have to grin and bear it in order to get the pictures."

Meter Maids, circa 1968

The so-called meter maids in Ottawa in the '60s were trained police officers in the early days of women being allowed to join the force. The disciplined sharpshooters had to begin their careers on the streets tending traffic and looking after parking meters.

Metal Workers, 1963

Surrounded by intense heat and sparks, metal workers in Ottawa pour molten metal with expert precision.

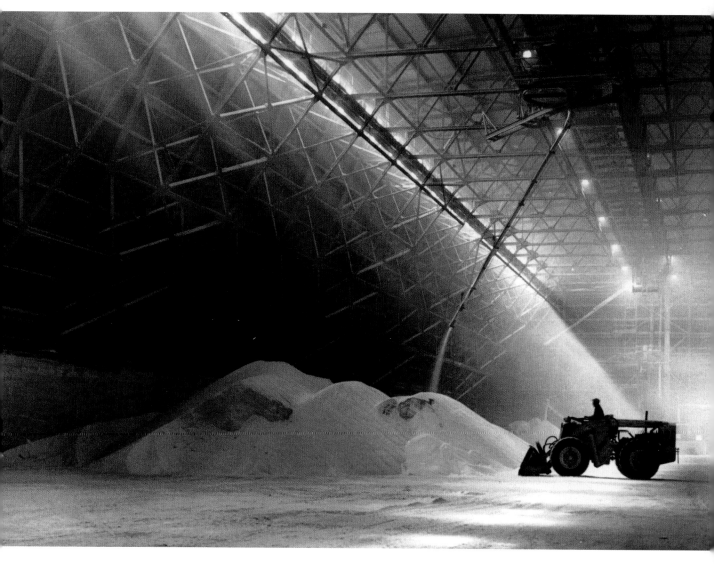

Tractor Driver, Potash Mine, 1968

A tractor driver at a high-volume potash mine in Saskatchewan diligently works with rich deposits of the minerals used in one of the world's most important fertilizers.

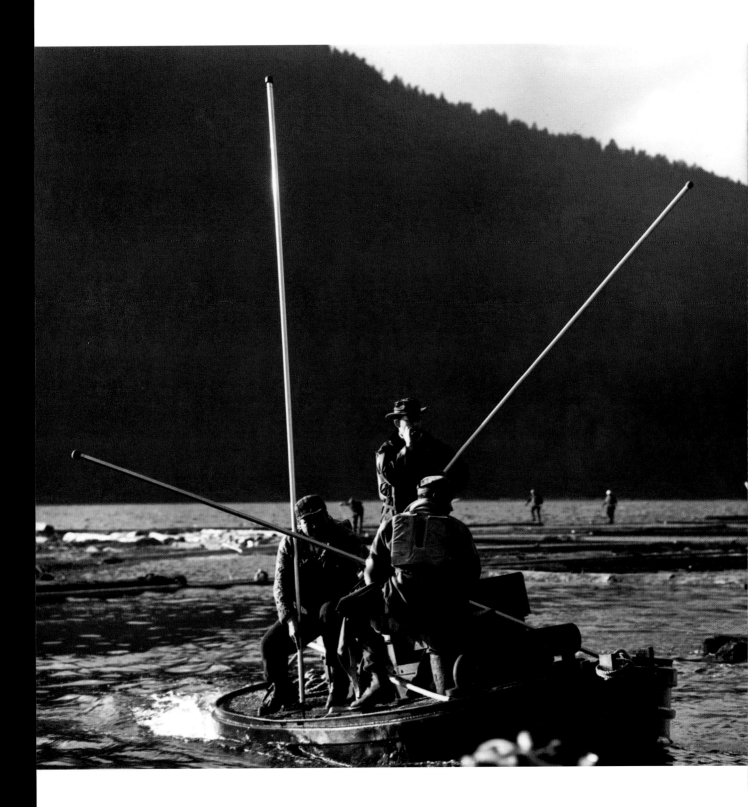

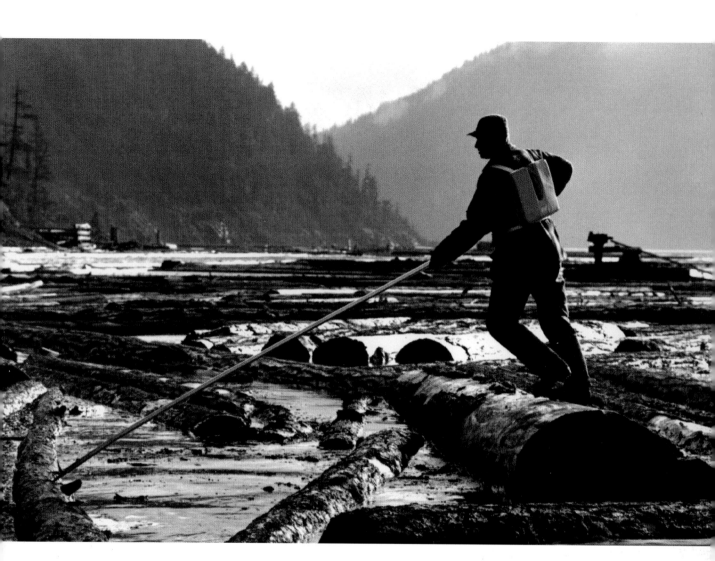

opposite **Log-Boom Attendants, 1967**

Freshly cut BC timber is safely transported to sawmills under the artful conducting of log-boom attendants with their four-metre-long pike poles extended. Eyes are alert. They work their fine craft quickly in order to get the logs in and out of the sea to minimize water damage.

above **BC Logger, 1967**

Sorting fir, cedar, and hemlock by species; lining up the parallel logs in the water; and getting them ready for a sea journey requires quick reflexes, good judgment, and a graceful dance step.

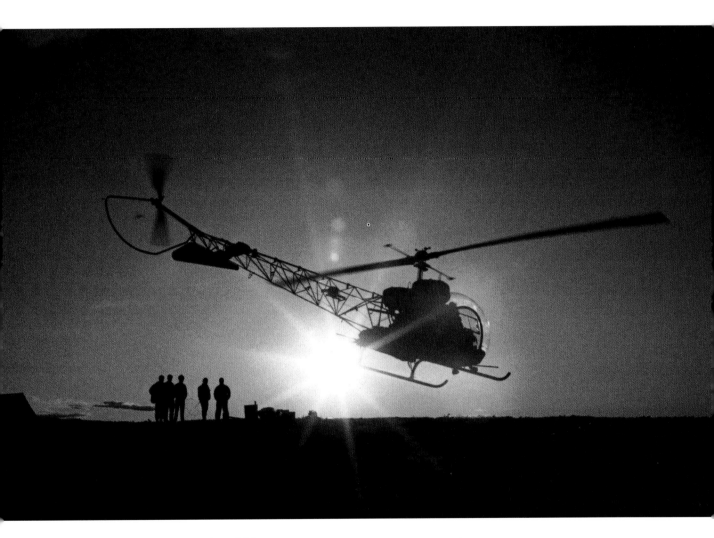

Helicopter, Copper Mine Exploration, 1964

A crew of five copper mine exploration workers are dropped by helicopter in the High Arctic.

"I nearly fell out of a helicopter one day when I didn't have a seat belt on in Northern Saskatchewan," Ted remembers. "An NFB movie cameraman and I were in the back seat. The movie guy was shooting first, with his door open. The plan was to do a second pass, and he and I would switch seats. When I moved over to his seat, the door swung open! Fortunately the guy beside me grabbed me fast enough. I was really lucky."

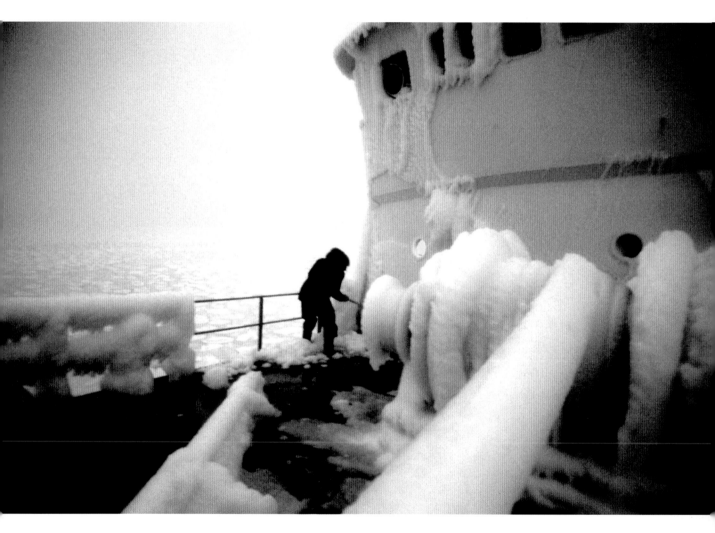

Iced Fishing Trawler, 1978

Off the coast of Dartmouth, Nova Scotia, the overnight ice build-up on a fishing trawler had to be removed with big hammers. The workers acted quickly to break off large chunks and kick them over the side before the build-up caused the ship to turn over.

Defrosting Northern Airplanes, 1967

Workers in Cambridge Bay, Northwest Territories (now part of Nunavut), use a heating unit
to warm and defrost airplane engines before they can take off.

RCMP on Duty, Civil Servant, and Visiting Dignitary Patrice Lumumba, 1960

An RCMP officer escorts newly elected Congolese prime minister Patrice Lumumba and a Canadian civil servant across the legislative lawns in Ottawa.

Okanagan Farmer, 1962

An elderly farmer with muscular arms tends her apple orchard in the Okanagan near the Trans Canada Highway. Ted stopped to say hello, and she took a break from her toil to chat and give him a sense of what life was like in the picturesque valley known for its fruit crops and, more recently, award-winning vineyards.

Fisherman at Lake Winnipeg, 1972

A fisherman pulls netting out of a hole in the ice on Lake Winnipeg in minus-forty-five-degree weather. Ted was lying on his belly on the ice, shooting through the net to catch the early morning light.

Ice Fisherman with a Good Haul, 1972

An intently focused and highly productive Arctic ice fisherman veers away from the crowd to work on his daily catch.

Vancouver Island Veterinarian, 1988

A Vancouver Island veterinarian kneels down to examine his patient.

Derrick Man, Oil and Gas Exploration, 1967

To get this shot, Ted stands behind a derrick man working on an oil-and-gas exploration platform in the prairies.

Mothering in the North, 1969

An Arctic mother keeps her baby wrapped up in snug layers and soothed by the sway of a homemade hammock.

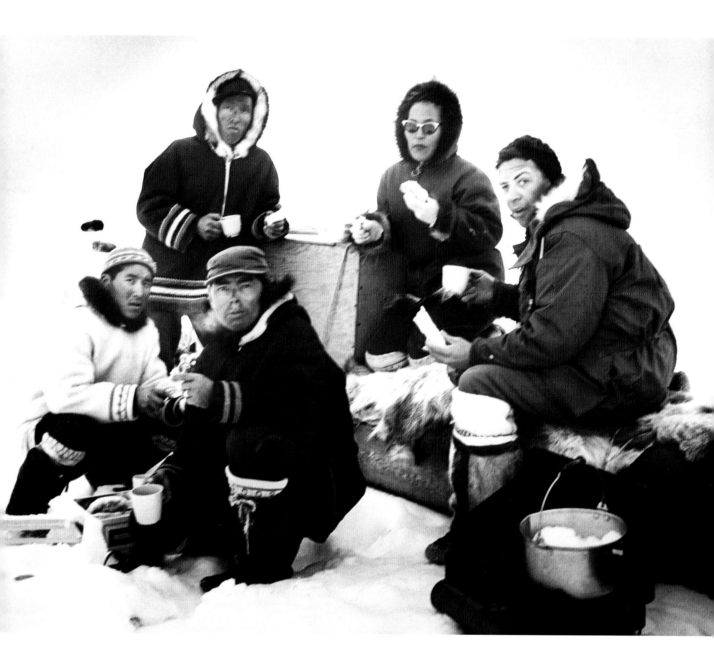

Ted (far right) with Inuit Family, 1969

Ted dines with a family after a seal hunting expedition in Frobisher Bay.

ALTHOUGH HE USUALLY did not have the luxury of time on his NFB assignments, as *National Geographic* photographers did on theirs (sometimes they got six months or a year to work on a feature assignment, whereas Ted typically had a week or two to cover several stories), Ted consistently took advantage of his innate ability to work with people.

I have photographed the downtrodden and the princes and the shahs and everyone in between. One common thread I learned is that once you have earned someone's trust, you must never do anything to break it. That rule has always been paramount for me.

When somebody asks me to talk about my career and the places I have been and the wonderful people I have met, I can be the gabbiest person in the world. I have enjoyed my work, and if I am lucky I will still do more. I want to make good use of every moment that I have left.

9 THOSE WHO CAN, TEACH

TED'S LEGACY

Ted Grant absolutely captivated and inspired the students. His time with us was the highlight of the semester.

SUSAN HAWKINS
History in Art Professor, University of Victoria, 2012

Dean Norris-Jones has been inviting the father of Canadian photojournalism to speak to his grade 10 photography students at Reynolds High School in Victoria every year for the past thirty years. Ted presents for an hour, and in recent years Norris-Jones has followed up the presentation the next class by showing *Ted Grant: The Art of Observation*, the hour-long documentary about Ted's life and work. The following semester, once the kids have absorbed a great deal about Ted's sixty-year career, Norris-Jones invites Ted back to the class for a dynamic Q&A session. As he presented Ted to his 2012 class, he reminded the students, "Whether you have been aware of it or not, Dr. Grant has had an indelible link to your mind's eye."

Ted begins the talk by asking how many students have cameras on them. Only four or five hands go up. Ted reminds them that they live on Vancouver Island, and when the big earthquake hits they'll need cameras to take the pictures they will be well positioned to sell afterwards.

opposite

Colosseum, Rome, 1967

A timeless shot from the Eternal City, this photograph of the Roman Colosseum still enjoys healthy sales decades after it was taken.

193

Lesson one: If you are a serious photojournalist, always have your camera ready and anticipate opportunities.

Taking pictures offers you the coolest life you can imagine. You are constantly alive with seeing the world differently. Photojournalism has taken me around the world. It gave me a magical career.

With that introduction, the teenage boy in the front row who has been eating a foot-long Subway sandwich puts it down. The unwrapped sub sits on the desk for the entire time that Ted is speaking. Forty non-texting sixteen-year-olds sit attentively for the duration of the octogenarian's presentation.

Ted's first slide point—"It isn't the camera; it's the holder"—offers the tech-savvy youth something to ponder.

"I am a photographer," Ted declares, "not a technician. When we focus on pixels and technology, we risk losing the photography impact moment."

Ted uses the podium opportunity as a chance to spread some of his own personal gospel to the youth. He reminds the students that the glory stories about war are not part of his experience. He remembers all too well when photojournalists and reporters have been killed in war zones.

I don't hear that well these days. I got my ears blown out as a photojournalist during the Arab-Israeli War. And by the way, don't sign up to be a war correspondent. It isn't remotely glamorous. You could be in the wrong place at the wrong time. And the reason for being there is usually about sheer stupidity.

I suggest you turn down those assignments. Don't put yourself in places where there is violence. If you really want to see something exciting, go up to northern Canada and photograph the polar bears. Or stay home and take pictures of the garden—and that can be extremely challenging, by the way—right in your own backyard.

Next, Ted advises the students to be sure to dress appropriately for each assignment. At this point, he leans toward the teacher and asks, "Can I say 'rat-assed' in here?" With the teacher's nod, he continues.

> Sometimes photographers look like a bunch of rat-assed bums. If you are at a G8 Summit with world leaders or dealing with a CEO who is wearing an expensive suit and shoes that cost who knows how much, you don't want to look as though you were just shot out of a cannon sideways. How you dress and how you speak to people will determine your future assignment offers.

He goes on to remind the students that they need to learn to work from the heart and learn everything they can about lighting. He talks to them about Rembrandt. He uses a series of his stellar photographs to demonstrate dynamic lighting. He talks to them about the 150 or so births and surgeries he has attended and photographed. Behind each image is a good yarn and a correlating, well-emphasized point.

Ted gets the students to start thinking about their own possibilities. He also mentions that his grandson took a photography course but is making more money delivering pizzas. He lets them know that photography is a tough way to make a living right now. With that understood, he carries on.

> Go up to Mount Tolmie and park your butt on a bench before sunrise. Watch the east and ask yourself, "What is the light doing to what I am watching?"
>
> You'll learn that you don't need to use flash. Flash is disturbing in most situations, and when you don't use it, people are less aware of what you are shooting. Flashes can often destroy what motivated you in the first place.

He tells more stories. He shows the stunning picture of the Barcelona diver in the 1992 Olympics. (See page 63.)

This is so easy you are not going to believe it. Here is the tip of the diving board at the far left of the picture. Use it to focus the camera. And then you wait. The diver leaps in the air, and you go click. *If you focus on the diving board, you have the shot.* Click. *And then you go for a beer.*

At the end of the lecture, Ted shows the picture of himself upside down in a fighter plane. (See page 131.) The kids initially laugh at the upside-down image until they realize it is not a mistake, and that this guy, who is easily old enough to be their grandfather, actually flew upside down in a Mustang P-51 fighter plane to celebrate his seventy-sixth birthday. And he photographed himself doing it. A noisy round of applause ends the class and several students linger to ask Ted questions.

Dean Myhal, who has been shooting as a hobby for five or six years and is currently taking photos for the Canadian Geographic Photo Club, quietly asks for Ted's autograph. He hopes to eventually get some work as a photographer.

"It's really cool to meet Ted," Myhal says, "I was excited about him being with us for this class. I have seen a lot of the pictures he showed us today but never knew they were his. The whole presentation was great, but his explanation about taking pictures from the shadow side was especially interesting to me."

Myhal's enthusiasm for Ted's work reminds me of Ron Poling, Ted's student at Carleton who went on to a successful career. They even look a little alike.

Counting Norris-Jones's students alone, Ted has influenced more than a thousand young photographers over several generations in Victoria, BC, over the last thirty years.

In the fall of 2012, Ted was a guest speaker at a photographers' conference in Wisconsin. He opened his presentation to a group of young photographers who were primarily interested in using their iPhone cameras better by encouraging them to shift their focus from the capabilities of technology to the principles of photography. These mentoring gigs are just one of the many ways Ted continues to give back to photography communities across North America. He usually gives at least half a dozen seminars a year and has no problem speaking to audiences of any size. After he presents, he tries to make time to chat one on one with as many people as he can.

"I have always made a point of that because sometimes people might be a little reluctant to ask questions in front of a group," he says.

Ted shows no signs of having spent his passion for talking about his lifework. Although he enjoys it immensely, it is not just the lecturing circuit that holds appeal; he still longs to do more hands-on work.

MANY OF TED'S colleagues from the early days became lifelong friends.

Steve Pigeon, president of Masterfile, is in the business of licensing stock photography primarily for use in advertising, design, and marketing. The Canadian company, now representing photographers from all over the world, currently has almost five million stock images.

> When I first met Steve he worked for the Montreal Star. He was a nice young chap who decided to start a photo agency in Toronto. I thought it was a great idea. I knew he was sharp at the business and saw his plan as a good thing for Canadian photographers. He was adding real value.
>
> The photo world is changing faster than you can spit, and the fact that Masterfile is now a large, successful Canadian company is mainly due to Steve's hard work.

When I caught up with Steve Pigeon in Toronto, the busy businessman spent an hour on the phone with me talking about how important Ted was to his career.

"When I met Ted, he was considered one of the greatest photojournalists in Canada, and I was just a kid barely out of high school," Pigeon says. "It was an honour to meet the guy. I am young enough to be his son, but he always made me feel like I was doing something of value.

"In 1973, I flew from Montreal to Ted and Irene's home in Ottawa for a meeting to look through some of his personal photographs and see what we could use in our company. It was one of the oddest business meetings I've ever had. He had an assignment to go to and left me alone in his home to look through his work. He just told me to close up his house when I was ready to leave. Ted always had a trusting nature.

"We are only a secondary source of income for Ted, but we still have over a hundred images of his in the Masterfile collection. The Colosseum photograph in Rome, for example, was taken in the '60s and is still being purchased.

"Ted is one of the guys I have to thank. He gave me the time when I really needed it and helped to get me where I am today. He was a great supporter and mentor."

Steve Pigeon is one of the two hundred friends that Ted calls early every Christmas morning. He gets up about 4:00 a.m., starting with friends in Europe and then working his way across the time zones. He spends the better part of the morning accomplishing his annual ritual. It is a just quick call to say hello and extend his best wishes. If he misses anyone, within days he gets a phone call or an email to see if everything is okay.

> It only takes a few moments with each person, and it makes Christmas as personal for me as knocking on their door, as though they lived down the street. Beats the hell out of sending a cold, lifeless card or an email.

WHEN BIL LINGARD'S daughter called to say that her father would be in Victoria and would like to visit, Ted laughed with sheer delight. "Is that old bugger still alive?" he asked of one of his early mentors.

More than fifty years after starting their photography business Photo Features, the two men sat at Ted's kitchen table reminiscing as old friends do. Bil Lingard and Ted had not seen each other since Bil moved to the US in the early '60s.

"When I first moved to the States, I was a guest lecturer at community colleges," Lingard says. "Students would ask what the most important thing is about being a press photographer. I would say, 'BE THERE.' You can write a story later, but you can't photograph an event after the fact."

Ted and Bil dove into a lifetime of subjects, both exhibiting a level of vitality rarely seen in octogenarians.

"I got a digital camera for fun a few years ago, when I retired at eighty-three," begins Lingard. "They are marvellous instruments."

Like Ted, Lingard knew early on that he wanted to be a photographer. Under the guidance of an uncle, he was developing his film in a pudding dish at eight years old. The uncle had an old quarter-plate fountain and a Reflex, an old English camera much like the Speed Graphic.

"I have worked with pretty well every camera," Lingard recalls, "but I don't think I will get an iPhone. I don't want to worry my mind about new equipment any longer."

Lingard told Ted about a pair of sandhill cranes he photographed at a tidal brook near his home in Florida. He said he was pleased with the result. "I could have sold it as a cover for *National Geographic*, but I decided I wanted it to be truly a limited edition. I made 24 x 30 prints for friends and family."

He described the painstaking process of capturing the perfect image of the majestic species.

"The pair of birds came down the creek by my house every day and I watched them for months and months. Those birds are over five feet tall, and I looked at them eye to eye when we were standing. I went out to observe them many times without shooting. I decided the picture had to be shot late in the day. And as they came down this particular day they were close enough. I made a noise and frightened them, and one of the birds lifted both of his wings and I got the shot.

"Ornithology-wise, the picture shows all characteristics of the birds. Both sides, male and female, wings outstretched and wings down, etc. Three years later I went back to exactly that site and the stream had dried up. There's been too much development in that area now—no more birds."

Bil described the image as the "best photograph of my working life."

The two men exchanged their feelings about having come through an amazing history of developing and using film.

"We prided ourselves on being photographers," Ted said.

"We made adjustments in the darkroom, using our hands to create a shadow. I mixed all of my developers from the chemicals—not a premixed product from Kodak," said Lingard. "I remember how I had to learn to improvise when I had an assignment to shoot the Knights of Columbus outside of the basilica in Ottawa after mass when the pope was visiting. I had been asked by an old French photographer who had given me retouching lessons to take the picture with my big panoramic camera that used ten-inch film. I prayed

for a dull day, but it was sunny and I had this big group of four hundred people, and half were in sunlight and half were in shadow. There was no way I could get a good picture. The camera went around on gears that gave the exposure. There was no shutter, only just a little slit, and the film went by the little slit depending on the gear you put it in. I looked over the top of the camera and when it came to sunlight, I retreaded it so it would take a longer exposure. I had to get the picture back to the old photographer later that day and he could hardly believe it. 'I don't know how you did it,' he said. So I explained that I had slowed the damn camera down so it would get a greater degree of exposure.

"I made my own contact sheets and used two fluorescent tubes with bulbs at the end, and with a little cloth over part of it I balanced the light on that negative from the sunlight. I had a lot of fun with that camera. I bought it from a Kodak salesman and paid a couple of hundred bucks, which was a lot of money then."

"When I think back to it, we never considered it work," Ted says. "It was fun and I would do it all over again."

The two men hope to visit their old hangout, the press gallery in Ottawa, during the next Canadian Tulip Festival.

I suggested they might not be able to get in, as there is pretty strict security there now.

"I'd like to see them try to stop us," they both chuckled. "We'll get in."

The sense of rebellion that fuelled their two long and successful careers is still highly visible today.

THE WALLS IN the family room of Ted's basement are filled with dozens of his awards. A huge collection of three hundred to four hundred books about photography goes back to the early 1900s. *The Romance of Modern Photography,* published in 1908, is just one of the lovely old tomes lining the bulging shelves.

There is the large signed and framed copy of John Travolta's picture from *Urban Cowboy.* There is a framed photo of Ted talking to Prince Charles. There is a dashing young Ted in a tux receiving an award. There is a Sandy Carter shot of Ted and Irene smiling on the day he received his honorary Ph.D. His children are in many of the shots

with famous personalities—Ted Jr., Cyndy, Sandy, and Scott are proud of their dad, and all have close relationships with him. The wood shelf containing a well-organized assortment of over three hundred pins collected from the many international events Ted attended was made by young Ted Jr.

At eighty-four, Ted has reflected on the kind of legacy he hopes to leave. In spite of the still-recent loss of his wife of sixty-three years, Ted is creating a satisfying existence. The legendary photojournalist is finding some delight in learning to shop and cook and clean house. He put up new pictures in the living room and is growing accustomed to the different feel of his solo path. Of course, he misses Irene; he misses her terribly. Her absence feels almost unbearable at times. But he still teaches and keeps in touch with old friends and continues to make new friends. He is still learning about life and blossoming. He still loves life as always.

> *I would like to leave a legacy where I was seen as a motivator and an inspirer of both amateurs and professionals. I would hope they might have learned something from a class I gave or from observing some of my work. I would like people to say: "He helped me."*
>
> *I have always felt that you get what you give in life. If you are working with someone and their camera breaks or stops functioning and you lend them a camera—the legacy you leave is that they remember you helped them, even if you were competitors.*

Ted lives to take photographs and has added substantially to the mythology of Canada with work that will never be dated. Ted's path was a calling. He jokes that he plans to be buried with a camera.

> *Given all the nearly killing, crashing, and crazy moments in my life, I am amazed that I have survived this long. And here I am in my eighty-fourth year, still shooting regular paying assignments that have been published in many newspapers across North America during the last couple of years! As long as I can see, feel the moment, and continue to love life, why wouldn't I continue the greatest love affair of my life?*

Toilet Paper Soldier, 1968

In 1968, a soldier and military photographer walks up to me and says, "You take my picture with this shovel and toilet paper and I'm gonna brain you." I think to myself, "Buddy that is a neat-looking photo, and I'm gonna shoot it. And in your condition I can run faster than you!" Decades later, when the soldier, Jim Cochrane, was president of the News Photographers Association of Canada and chief photographer for the *Edmonton Journal*, he invited me to give a presentation at their conference. I couldn't resist showing the shot of him with shovel and toilet paper in hand. Surrounded by many of his colleagues from western Canada, he took it in good stride and thought it was hysterical. I always use it to end my presentations. People get a laugh out of it.

Washerwomen, Spain, 1962

While Ted was shooting at an Interpol conference in Madrid in 1962, he took an afternoon walk in the countryside and photographed a group of women washing and folding clothes. The bareness of the landscape and simplicity of the architecture contrasts with the bustle of activity as the women go about their work. This shot is yet another example of Ted's skill as a "quiet observer."

AFTERWORD

When my friend Jackie Evans Travland died at age fifty-four of ovarian cancer, I pitched a story about the disease to the Victoria *Times Colonist*. Lucinda Chodan, then editor-in-chief, called me two weeks later and invited me to write a column about the people who live in high-end homes in our community. That threw me.

"I don't know anything about high-end homes," I said.

"You are good at writing about people," she responded. "That is what I am after."

I was shocked and thrilled. Not many writers get cold-called these days to write a weekly column for a mainstream newspaper. I told Chodan I would be happy to write it, but would like to work with Ted Grant as the photographer.

"Wouldn't we all," Chodan cheerfully replied. But she said she doubted they could afford him. I suggested if they came up with an offer, my old teacher might be available and willing to do the job. She offered $650 a week for one thousand words and a selection of pictures. I knew it was not a great offer, but I agreed to it.

I insisted Ted take $350 and I take $300. He argued that we should split it, but I held my ground. I was happy to get the chance to work with him and knew it was a fraction of his normal rate. Irene said it would do him good to get out and take some pictures. I promised to do the legwork in finding and arranging interviews and picking Ted up and driving him home. I suggested it would only take him a few hours a week. He was pleased with the arrangement and figured it would be a breeze.

Chodan was great to work for and appreciated the prestige of Ted's involvement with the paper. I did not expect the column to be of much interest outside of Victoria, but many of the Postmedia family papers across the country regularly picked it up. According to friends in my hometown, the *Montreal Gazette* featured it prominently most weeks.

opposite

Mike Brodsky, 2009

Exhibiting a vitality reminiscent of Ted himself, ninety-one-year-old Mike Brodsky shows that age and disability are no match for joie de vivre as he paddles down the Gorge fjord in Victoria, BC.

After visiting the first few houses, Ted and I developed a little ten-minute drill designed to make people comfortable when we arrived. It can be nerve wracking for some to invite strangers armed with cameras and notepads into their home, but all of my recordings capture terrific laughter and friendly chatter minutes after our arrival. Ted's easy professionalism and ability to make people comfortable was interesting to observe and learn from. Ideal teamwork evolved.

Readers quickly got tired of seeing the opulent homes, and every time we featured another one, there would be an outpouring of complaints and suggestions that we profile more "normal" homes and less "house porn." Featuring less opulent homes, and focusing more on the people was a natural evolution for me. I was always more interested in the people than the building.

One of my favourite columns was a story about ninety-one-year-old Mike Brodsky, who decided to upsize from a small townhouse to a three-bedroom home with a yard. Not opulent by any stretch, but he fell in love with the house for its large kitchen counters—he loved to make his own bread. This high-functioning elderly man had suddenly gone blind when he was in his early fifties. He was a fabulous character, full of life and fun, and had just recently "got back into canoeing." He and Ted got on famously.

In fact, Ted was so intrigued with Brodsky's canoeing skills that he offered to follow him down a fjord in Victoria. I held on to Brodsky's guide dog by the shore and watched Brodsky, the nonagenarian, paddle with Ted, the octogenarian, in a canoe behind him, taking pictures. Watching the two spirited men enjoying themselves was inspiring. I wrote two stories about Brodsky—one for cbc.ca called "Rediscovering Canoeing at 90," and one for my House Beautiful column called "Convenience is Critical for Blind Homeowner." Both stories were huge hits with readers.

I had a ball writing the House Beautiful column over that year and wondered if my friend Jackie had pulled some strings from beyond to help get me such a great writing gig. While working with Ted, I learned most of what I have written about in this book. And I probably would not have written it without Chodan's original invitation to write the column. One thing quite naturally led to the other. The more I learned about Ted Grant, the more certain I was that Canadians would enjoy knowing more about the inspiring teacher I met at Camosun College twenty-five years ago. My goal with this book is to tell a story in a sensitive manner about an artist whose rich sense of humanity is at the core of his work.

APPENDIX

CARRY RAISINS AND OTHER TED COMMANDMENTS

As I created transcripts of more than fifty interviews with Ted, I amassed scores of tips for would-be photojournalists. Here are some of them.

ON ANTICIPATION

Get to the assignment early, keep your eyes open, and plan. Work through the scenario in your head. How do you think things will play out? If so-and-so is coming through the door, are they going to leave through the same door? Is anyone going to interact with them that you can set yourself up with in advance? If the politician is working their way out of the room, is there some little old lady you know he will be stopping to talk to? If so, you can get up forty seconds before the politician and place yourself. Anticipate, observe, and be ready.

ON BEING PREPARED

If you have a camera on your shoulder, it should be ready to rock and roll. Don't carry it with a lens cap on. It's hanging on your shoulder; the lens is safe. If you drop it, you are going to have to get a new camera. The lens cap won't make much difference if it's on or off.

I love the digital camera because it allows me to capture what I see. You don't have to carry a thousand rolls of film or consider film cost, which once may have caused me to hesitate.

ON BLACK AND WHITE

A huge part of my career was shot in black and white, particularly my documentaries for the National Film Board. When you photograph people in colour, you photograph their clothes. But when you photograph people in black and white, you photograph their souls.

ON BREATHING

If you are shooting with a long shutter speed, use a chest-pod or brace yourself. Take a deep breath. Exhale, and then hope the moment you want to capture happens when you are not breathing. Don't jab the shutter. Squeeze it gently. That is how to make the image sharp.

Leicas help you do that because they are made of glass and brass and are heavy. In the Leica schools, they teach you how to use the mass of the camera on your elbows. There are things you learn by using different equipment.

ON CARRYING RAISINS

On assignment, I always have a large bag of Thompson raisins in my suitcase in the hotel. I use it to fill up my camera-bag container every day. Raisins are essential equipment.

When I show up five to six hours early at a sporting event to stake out the best vantage point, I don't want to have to leave an hour before the start time to go and get some food. And if another photographer is nearby and in the same predicament, I usually have enough provisions to help out.

Once I was invited to British Columbia to photograph heli-skiers. The chopper pilot leaves me there and says he will be back "shortly." After three hours—without skis—I was a little concerned. I began to wonder how I could get down the mountain, but realized that there was no way. I would have to wait. No problem. I had raisins.

They were always a quick hit of something to eat if I was working the oilfields, or the Olympics, or with a prime minister.

You make friends with other photographers at the Olympics even though you only meet every four years. And the other guys knew I always had raisins and would share them with starving photographers. When you give kindness, you are going to get kindness back. And you have about four months before the raisins will walk away on their own.

ON THE COMPETITION

How will they look at the subject? Can you outfox them by being the only person with a particular lighting and angle?

ON COMPOSING A PICTURE

Walk around the subject. Pick the angle. Have unlimited patience when waiting for a picture.

ON CROPPING

Crop in the camera. You move and do what is necessary to capture the photograph in the frame. Do it that way so that those x&^%&#$ editors won't screw up your pictures!

ON DELETING SHOTS

Never edit or delete anything until you are looking at large shots on your computer screen. It is too easy to miss a good detail if you are deleting off the back of the camera.

ON EATING SUSHI

Real photographers shoot black and white, eat sushi, and drink single malt Scotch.

According to Ted's former student Ron Poling, who was introduced to sushi by Ted in Montreal at a Grey Cup game, "eating sushi while on assignment with Ted was mandatory."

ON EDITING IMAGES

Don't consider sharpness of an image in isolation. Could something be sharper? Maybe. But is it interesting? That's important. Get over the lack of sharpness.

Is it a Pulitzer Prize-winning photo? Maybe not, but is it interesting? Look at the content.

ON EYES

Study the eyes of the people you are photographing.

ON FLASH

Some people say you have to use flash. My feeling is that if you can see something, you can shoot it—at ASA [measurement of film speed] 800 or 1,600 or 3,200. Don't worry about a bit of grain. If you are shooting by candlelight, it might add to the quality of the picture. But don't worry; focus on the content of the picture.

ON GIVING BACK

You have to give back. Never say no to helping someone out. Give, give, and give.

"If you walk into any newspaper in the country, they will know Ted Grant's name because of his reputation for giving back," former colleague John Harquail says.

ON HANDLING SUBJECTS

How you handle and relate to people is critical to your success. Your mannerisms and the way you speak is important to the outcome.

I spoke to people and made them comfortable in the way I talked to them. We were one, so to speak. The tone of your voice is important. Speaking down to people is the wrong thing to do. Don't put pressure on people and don't give them the whole story of what you are trying to do. They probably don't need to know.

Minimize the posing. Always try to have your subject do something that is very natural for them, rather than get them to smile for the camera.

ON iPHONES

It is an interesting instrument, but I wouldn't hang up my Leica just yet.

ON KEEPING FIT

Keep fit.

When asked for his impression of watching his father do eighty sit-ups at his eightieth birthday party, Scott Grant put it this way:

"He just dropped on the deck at our family gathering, and everyone was wondering what he was doing. He went through it all, and it was good to see. I knew he had been working toward it. The majority of people couldn't do eighty sit-ups—never mind people his age. But he has always been able to keep up. He always ran with the younger guys who were in better shape. He always worked at it and he knew the importance of it."

ON KEEPING HARD COPIES

A CD of photographs can be expected to last for only ten years. The future of archived CDs is questionable. Keep well-protected hard copies of your best work.

ON LEICA CAMERAS

A Leica is magical, but it is almost out of the realm of reasonable reach for most people. Those cameras have a strong history of having been used by the greats. At one time I had three, but one of those cameras today is $22,000. Buying an iPhone for $500 is an easy choice for most people.

If I were still shooting documentaries, I would order three Leica digitals, but I can't justify that now. I expect Leica will evolve and continue to offer the finest tools in the world. A $22,000 Leica can produce brilliant shots, but you need to understand the principles of photography. Seasoned staff photographers all over the world have

been laid off, but their work has yet to be replaced with photographs of the same level.

ON LETTING GO OF IRRITATIONS

Get beyond things that aren't worth carrying.

"Ted can't go ten feet without meeting friends," says Ron Poling, "because he is able to let go of things. He would get frustrated with work or people at times, but then he would let it go."

ON MAKING MISTAKES

I was once assigned to photograph Governor General Vincent Massey. When I got to the darkroom and developed the film I realized I had blown the shot. I called and asked if I could go back right away to do a reshoot. Massey, being the gentleman he was, said yes. It worked beautifully.

ON MAKING THE MOST OF AN ASSIGNMENT

Always be first to arrive and last to leave.

ON MULTITASKING

At the Olympics when they hang the medal around the athlete's neck and the Canadian flag goes up and the national anthem begins, I am usually trying to manage a big long lens, focus, and compose the shot—and I am trying to do all that while crying.

ON NEW TECHNOLOGY

There was a time when painters thought photography would spell the ruination of their art. And of course, the painters who learned to take photos and use them to their advantage in creating their paintings, they were the ones who appreciated the new technology. The same is true today with digital technology.

My old darkroom in the basement has been transformed into a digital office storeroom. It still has the remnants of the wet trays and darkroom

sink, but it now has racks full of CDs and back-ups of everything. The trays with various chemicals and a print-wash to wash the chemicals out of the photos and the drier are all still nearby.

I could take everything out of there and turn it into a darkroom in half an hour if I needed to—not that that will likely ever happen.

"In the '50s, Ted's early use of 35 mm film was part of the revolution in which photographers finally shifted to a different way of technically approaching their subjects. Portable equipment gave photographers a different ease in the way they could take pictures," says Lilly Koltun, retired director general of the Portrait Gallery of Canada.

ON OBSERVING

Use your eyes for more than avoiding the garbage can in your path. If there are no pictures, you are not looking. Feel the environment. Sometimes it takes time to get into that kind of groove.

No matter how observant you think you might be, you have to teach yourself to really see. It is demanding to constantly use your eyes to appreciate water drops on a flower or the light of the day.

ON ONE-SECOND EXPOSURES

On a number of occasions I made one-second exposures with my Leica. I can't do it any more with my slightly shaking hand. But then I had a way of standing and locking my body to keep completely steady. A one-second exposure is slow. Today cameras can shoot one–eight–thousandth of a second. A one-second exposure is a lot of time. You would use that for a low level of light. If you deliberately move the camera, it will create a swish or a blur to portray movement.

ON POSING PEOPLE

Don't pose people. If you have to, get people to focus on something to do so that they are not thinking about you taking their picture. And

for heaven's sake, get away from the "look over here, Grandpa is going to take your picture" approach! You have just seen the child playing in the most gorgeous sunlight in the living room, and the light is coming through the window. Capture the moment that triggered you to want to take it in the first place.

ON POSITIONING YOURSELF

Understanding light is one of the key elements of successful picture taking. It makes all the difference in the world. A slight move to the right and shadows and highlights begin to work together. With architectural photography, you can move to the shadow side and make a cathedral look as a structure of beauty beyond your wildest imagination rather than a flat image. I want people to know that if they take five steps to the left, they might have a brilliant photograph.

ON PROMISING PHOTOS

Never promise someone that you will send photos and not send them, because they will meet you ten years later and remember. I will often ask people for a card and note their request on it.

ON RESPONDING TO YOUR GUT

If you react to something, shoot it. Don't use your analytical brain because if you think too much, you will miss out on the greatest shots. With film, we were more inclined to see how many frames were left on a roll. But today, if you see something that catches your eye, shoot it. It doesn't even cost you.

ON SEEING THE WORLD

iPhones and other technology are wonderful, but something is lost when we are busy texting and missing the world we are travelling through. There is so much to see in life. When I see people texting, I am sad that they are not going to see what I have seen. If you are texting as you drive through the Rockies, you are missing out.

ON SELECTING YOUR VANTAGE POINT

In Cali, Colombia, in 1971 at the Pan American Games, a Canadian woman horseback rider came off the horse and went right under the water. She amazingly came back up and still had the reins in her hand. The Canadian equestrian team won gold that day.

You know that these kinds of things happen, so if you are photographing an event where horses and riders are involved, go to the waterhole because that is where the cool pictures happen. Go where the action is.

ON SHIFTING SOMEONE OUT OF A PICTURE

If you work with officialdom, there can be times when people try to ease themselves into shots to be seen with high-level people. When someone tries to drift into a picture this way, never be offensive, but you can lightly suggest something like, "Okay, you in the back, could you just slip over this way a little?" Do it in a nice way.

ON SHOOTING FROM THE SHADOW SIDE

I wasn't even aware that I was "shooting from the shadow side" until Ron Poling, a student of mine at Carleton, told me. It was just how my one eye saw the world.

ON SIGNING RELEASES

None of the cowboys I shot signed releases—same for the medical photos. The families of my subjects would likely be honoured. There is nothing embarrassing in anything I have shot. I didn't go looking for yellow journalism pictures.

ON SPORTS PHOTOGRAPHY TRAINING

Go to local games and learn where to sit. Explore.

ON TEACHING OTHERS

Listen carefully and understand where students are coming from.

Carol Goar, a veteran columnist at the *Toronto Star*, was another of Ted's students at Carleton University. Goar remembers Ted fondly for his patience with the students who had no natural ability with photography. She considered herself one of them.

"Ted was so patient and supportive. He spoke in plain language and explained things well. We knew we were hearing from a working photojournalist at the top of his game. He always seemed ageless to me, even when we spoke in the last few years. One of his medical photography books has a treasured place on my bookshelf."

ON WONDERING

I was sitting on my front steps by a huge patch of daisies watching some bees hovering, and I wondered what I could do with a 400 mm lens.

The bee was about to land when I took the picture. (See page 96.) But it wasn't until I looked at it on the screen that I could actually see it hovering and coming in for the landing. It would be almost impossible to see the bee and the shadow through the viewfinder at the same time— you don't have time to consciously process that. You do get lucky from time to time.

I encourage you to have as many "I wonder what if" moments as you can.

LIST OF WORKS

John Evans Portrait Shot of Ted Grant, News Photographer—Ted Grant Private Collection, 1953. Photograph by John Evans.

Sixtieth Anniversary—Ted Grant Private Collection, 2009

Wedding Day—Ted Grant Private Collection, 1949

Ted and Irene on the Street—Ted Grant Private Collection, 1952

Ted and Irene on a Motorcycle—Ted Grant Private Collection, 1948

Ted and Staghound—Ted Grant Private Collection, 1951

Ted in Stock Car—Ted Grant Private Collection, 1952

Copy of Negative of Stock Car—Ted Grant Private Collection, 1952

Ted and Newton Photography Sign—Ted Grant Private Collection, 1954

Speed Graphic Shot—Ted Grant Private Collection, 2012

Ted—New Photographer and Baby on Street—Ted Grant Private Collection, circa 1952

Rolleiflex Camera—Ted Grant Private Collection, circa 1955

Inuit Cowboy Kid with a Toy Six-shooter—National Film Board Assignment, Ted Grant Private Collection, 1958

Rugged Cowboy with One Eye—National Film Board Assignment, Ted Grant Private Collection, 1965

Cowboy Napping in the Bunkhouse—National Film Board Assignment, Ted Grant Private Collection, 1966

Cattle Drive—National Film Board Assignment, Ted Grant Private Collection, 1966

Wild Horses—National Film Board Assignment, Ted Grant Private Collection, 1966

John Travolta Lasso Shot—Ted Grant Private Collection, 1978

Africville—Library and Archives Canada, 1965

Ottawa Slums (a)—Library and Archives Canada, 1953

Ottawa Slums (b)—Library and Archives Canada, 1953

Ottawa Slums (c)—Library and Archives Canada, 1953

Boys' Club Haircut—Ted Grant Private Collection, 1962

Crying Boy Haircut—Ted Grant Private Collection, 1965

Start-line Hands—Ted Grant Private Collection, 1972

Bruce Simpson Olympics—Ted Grant Private Collection, 1972

Ben Johnson 9.79 Seconds in Seoul—Ted Grant Private Collection, 1988

Upside-Down Horse Rider in Cali, Colombia, Pan Am Games—Ted Grant Private Collection, 1971

Skater Calgary Olympics—Ted Grant Private Collection, 1988

Barcelona Olympic Diver—Ted Grant Private Collection, 1992

Barcelona Diving Board—Twenty Years Later—Ted Grant Private Collection, 2012

Pierre Trudeau—Ted Grant Private Collection, 1968

Ron Lancaster—Library and Archives Canada, 1974

John Diefenbaker and Tommy Douglas Laughing—Ted Grant Private Collection, 1962

Tommy Douglas for Leader—Library and Archives Canada, 1961

John Diefenbaker and Baby Catherine Clark at Stornoway Garden Party—Ted Grant Private Collection, 1978

Joe Clark—The Public Professional—Ted Grant Private Collection, 1974

Joe Clark and Maureen McTeer—Ted Grant Private Collection, 1980

Joe Clark—The Private Professional—Ted Grant Private Collection, circa 1980

Madame Vanier and the Dropped Purse—Ted Grant Private Collection, 1961

Inspection—Ben-Gurion's Hair—Ted Grant Private Collection, 1961

Margaret Thatcher and Ronald Reagan—Ted Grant Private Collection, 1981

House of Commons—Flying Paper—Ted Grant Private Collection, 1960

House of Commons—John F. Kennedy—Ted Grant Private Collection, 1961

Windy, Wintry Ottawa Day—Bundled Old Man—Ted Grant Private Collection, 1962

Mountbatten at the Calgary Stampede—National Film Board Assignment, Ted Grant Private Collection, 1967

Rolls-Royce—National Film Board Assignment, Ted Grant Private Collection, 1964

D'Iberville *Icebreaker in the High Arctic*—National Film Board Assignment, Ted Grant Private Collection, 1957

Chinatown—Elderly Gentleman and Pet Bird—National Film Board Assignment, Ted Grant Private Collection, 1963

Chinatown—Studious Girls—National Film Board Assignment, Ted Grant Private Collection, 1963

Chinatown—Dad Feeding Son—National Film Board Assignment, Ted Grant Private Collection, 1963

Young Canadians Making Music in the Park in Victoria, BC—National Film Board Assignment, Ted Grant Private Collection, 1962

Stanley Park Flower Power—National Film Board Assignment, Ted Grant Private Collection, 1963

Molson Beer Truck and Hitchhiker—National Film Board Assignment, Library and Archives Canada, 1967

Moscow—Young Military Men in Red Square—Ted Grant Private Collection, 1992

Moscow Streets—Elderly Cleaning Woman—Ted Grant Private Collection, 1992

Busy Hands in Conversation in Rome—Library and Archives Canada, 1967

Oktoberfest German Barmaid—Ted Grant Private Collection, 1962

Stockholm Kids Playing Hockey—Library and Archives Canada, 1969

Elderly Students Creating Art in Victoria, BC—Ted Grant Private Collection, 2002

Bee Shadow—Ted Grant Private Collection, 2003

Robert Stanfield at the Opening of Ted's People of the World! *Exhibition in Ottawa*—Ted Grant Private Collection, 1979

Martha in Green—Ted Grant Private Collection, 1969

Martha Chatting with Neighbour—Ted Grant Private Collection, 1969

Swirling Photo—Ted Grant Private Collection, 1969

Bubble Bath at Her Apartment—Ted Grant Private Collection, 1969

New Costume—Ted Grant Private Collection, 1969

Getting Ready to Go Out—Ted Grant Private Collection, 1969

Relaxing with Friends—Ted Grant Private Collection, 1969

Two Faces of Martha—Ted Grant Private Collection, 1969

Smoking Some Hash—Ted Grant Private Collection, 1969

Stoned Photographer—Ted Grant Private Collection, 1969

Looking Out—Ted Grant Private Collection, 1969

Martha Relaxing with Her Roommate—Ted Grant Private Collection, 1969

Close-up—Ted Grant Private Collection, 1969

Looking Out on NYC—Ted Grant Private Collection, 1969

Karsh Winner—Indian Princess—National Film Board Assignment, Ted Grant Private Collection, 1969

Not a Karsh Winner—Princess with Grandmother—National Film Board Assignment, Ted Grant Private Collection, 1969

David Ben-Gurion—Ted Grant Private Collection, 1961

Jackie Kennedy Watching the RCMP Musical Ride in Ottawa—Ted Grant Private Collection, 1961

Charlotte Whitton—Ted Grant Private Collection, 1958

Nun in Training—National Film Board Assignment, Ted Grant Private Collection, 1965

Bobby Orr—Ted Grant Private Collection, 1969

Grandma Irene Grant—Ted Grant Private Collection, 1994

Tangerine Farmer in Japan—National Film Board Assignment, Ted Grant Private Collection, 1968

Dr. Jim Dutton—Ted Grant Private Collection, 1983

America Never Fails—Ted Grant Private Collection, 1962

Ted Grant, Self-Portrait at Seventy-Six Years Old—Ted Grant Private Collection, 2003

Dr. Brien Benoit—Ted Grant Private Collection, 1979

First Time for Mother Holding Hands with Her Child—National Film Board Assignment, Ted Grant Private Collection, 1976

Father Holding Mother's Head to See Their Child—National Film Board Assignment, Ted Grant Private Collection, 1976

Leopard-hatted Surgeon—Ted Grant Private Collection, 1985

Dr. Jim Dutton—Ted Grant Private Collection, 1985

Sue Rodriguez with Support—Ted Grant Private Collection, 1993

Montreal Children's Hospital—Sticking Out Tongues—Ted Grant Private Collection, 1985

Chernobyl Child Sticking Out Tongue—Ted Grant Private Collection, 1992

Chernobyl Boy and Car—Ted Grant Private Collection, 1992

Chernobyl Boy before Testing—Ted Grant Private Collection, 1992

Chernobyl Boy Being Tested—Ted Grant Private Collection, 1992

Sandy Carter with Ted—Ted Grant Private Collection, 1988

UVic Medical Students—Ted Grant Private Collection, 2012

Ted Organizing UVic Medical Students for Grad Class Photo—Ted Grant Private Collection, 2012

Dr. Ted, as He Is Affectionately Known, Receiving an Honorary Degree—Courtesy of Sandy Carter Photography, 2008. Photo by Sandy Carter.

Ted as a War Correspondent—Ted Grant Private Collection, 1968

Victorious Israeli Soldiers—Ted Grant Private Collection, 1967

Defeated Egyptian Soldiers—Ted Grant Private Collection, 1967

Young Canadian Soldiers at the War Games in Norway—National Film Board Assignment, Ted Grant Private Collection, 1968

A Padre at the War Games in Norway—National Film Board Assignment, Ted Grant Private Collection, 1968

Motorcycle, Saigon—Ted Grant Private Collection, 1968

East Coast Fisherman Playing Cards—National Film Board Assignment, Ted Grant Private Collection, 1968

Fishing Plant—National Film Board Assignment, Ted Grant Private Collection, 1968

Meter Maids—Library and Archives Canada, circa 1968

Metal Workers—National Film Board Assignment, Ted Grant Private Collection, 1963

Tractor Driver, Potash Mine—National Film Board Assignment, Ted Grant Private Collection, 1968

Log-Boom Attendants—National Film Board Assignment, Ted Grant Private Collection, 1967

BC Logger—National Film Board Assignment, Ted Grant Private Collection, 1967

Helicopter, Copper Mine Exploration—National Film Board Assignment, Ted Grant Private Collection, 1964

Iced Fishing Trawler—National Film Board Assignment, Ted Grant Private Collection, 1978

Defrosting Northern Airplanes—National Film Board Assignment, Ted Grant Private Collection, 1967

RCMP on Duty, Civil Servant, and Visiting Dignitary Patrice Lumumba—National Film Board Assignment, Ted Grant Private Collection, 1960

Okanagan Farmer—National Film Board Assignment, Ted Grant Private Collection, 1962

Fisherman at Lake Winnipeg—National Film Board Assignment, Ted Grant Private Collection, 1972

Ice Fisherman with a Good Haul—National Film Board Assignment, Ted Grant Private Collection, 1972

Vancouver Island Veterinarian—Ted Grant Private Collection, 1988

Derrick Man, Oil and Gas Exploration—National Film Board Assignment, Ted Grant Private Collection, 1967

Mothering in the North—National Film Board Assignment, Ted Grant Private Collection, 1969

Ted (far right) with Inuit Family—National Film Board Assignment, Ted Grant Private Collection, 1969

Colosseum, Rome—Courtesy of Masterfile.com, Steve Pigeon Collection, 1967

Toilet Paper Soldier—National Film Board Assignment, Ted Grant Private Collection, 1968

Washerwomen, Spain—Ted Grant Private Collection, 1962

Mike Brodsky—Ted Grant Private Collection, 2009

Ted Grant—Ted Grant Private Collection, 2004. Photograph by Sandy Carter.

INDEX

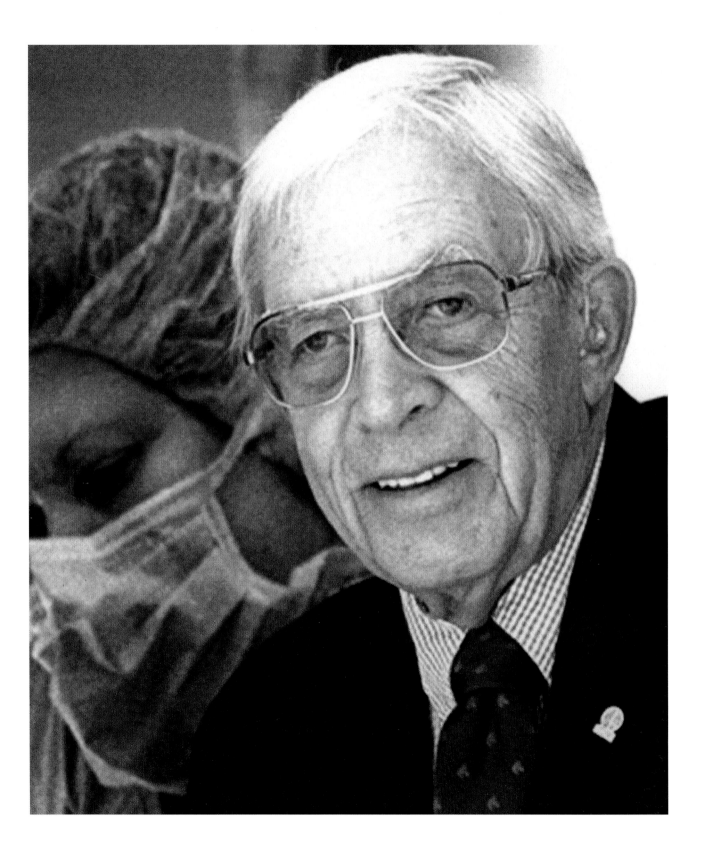

ACKNOWLEDGEMENTS

Ted Grant: Sixty Years of Legendary Photojournalism would not exist without the hard work of Ted Grant and the support of the late Irene Grant. It was pure joy to be inspired over and over again by their teamwork and by Ted's joie de vivre that shone through in both his captivating photos and in his gentle, intelligent, and respectful manner.

Losing Irene in the process of writing this book created a large, grief-filled pause, followed by a determination to honour her memory. I hope the reader and, more importantly, Irene's children and grandchildren, will feel that I have done that. Thanks to Ted Jr., Cyndy, Sandy, and Scott for their abundant insights.

After rejections from a dozen publishers, I am deeply grateful to Heritage House Publishing Co. for their decision to work with an unknown writer. The process of working with the talent at Heritage House was almost as fine and fun as working with Ted Grant. Thank you especially to Kate Scallion for firm and gentle stick-handling, and to Lara Kordic, the most respectful editor I have met.

When I handed over a personal letter from Ted to the staff at Library and Archives Canada and the National Gallery, requesting their full cooperation with my goals, doors opened for me. I had access to all of Ted's work along with the most gracious help from knowledgeable people. What will the National Gallery do when Sue Lagasi retires? She knows the collections inside out and was a pleasure to work with. Thank you, Sue. And to the folks at LAC that I have already mentioned by name in the text—thank you for unlocking the vault to Ted's work. Your help was a critical part of the process. I shudder to think what might happen if the archives are not properly funded in future and you are not there for the other Canadians who want to better understand our past.

opposite

Ted Grant, 2004

This photo of Ted was taken by Sandy Carter when they collaborated on the book *Women in Medicine.*

My gratitude goes to the many people who allowed me to interview them and gain a greater sense of their experiences with Ted. Ron Poling, John Harquail, John Ough, Hélène Proulx, Steve Pigeon, Maureen McTeer, Sandy Carter, Heather MacAndrews, Dave Springbett, Carol Goar, Lindsay Crysler, Susan Hawkins, Dean Norris-Jones, Joan Schwartz, Quinton Gordon, Robin Rawson, and Margaret Wood. You went out of your way for me. Thank you so much for your time and your warmth, and most of all your generosity of spirit.

Katherine Gibson, you are a wonderful writer and role model. Your beautiful work on Ted Harrison initially inspired me to write this book.

Gail Kirkpatrick, Kathy Vanderlinden, Suzanne Morphet, Rosemary Neering, and Peter Grant are just a few of the PWAC members who have helped me learn more about my late-in-life-acquired craft. I am grateful to call you friends and proud to know such beautiful writers. And to Sylvia Olsen, another fabulous writer, thank you kindly for advice on approaching my research at the archives. That was a very productive couple of hours at my kitchen table.

Dr. Phyllis Jensen, although we met only very briefly over lunch, your appreciation and understanding of Ted's work and my communication goals with this book brought me to tears. I can understand why you chose to work with Jungian psychology.

Lynne van Luven, Stephen Hume, Lorna Crozier, and Joyce Nelson are just a few of the wonderful profs at UVic who made late-life learning worth going to school for after being at work all day.

I offer my deepest gratitude to my nourishing circle of family and friends—how did I get so lucky? You have been my best teachers in life—especially Mom (Thelma Sr.) and her "gumption." You gotta love those hearty Norwegian/Newfoundland genes.

To Daryl Jones, who accompanied me on the long train ride to Ottawa, I wish to express a deep and loving appreciation for all of the things you always do so beautifully for me—especially the way you make me laugh.

And thank you for reading this book.

—THELMA FAYLE